CHARLES

Demuth

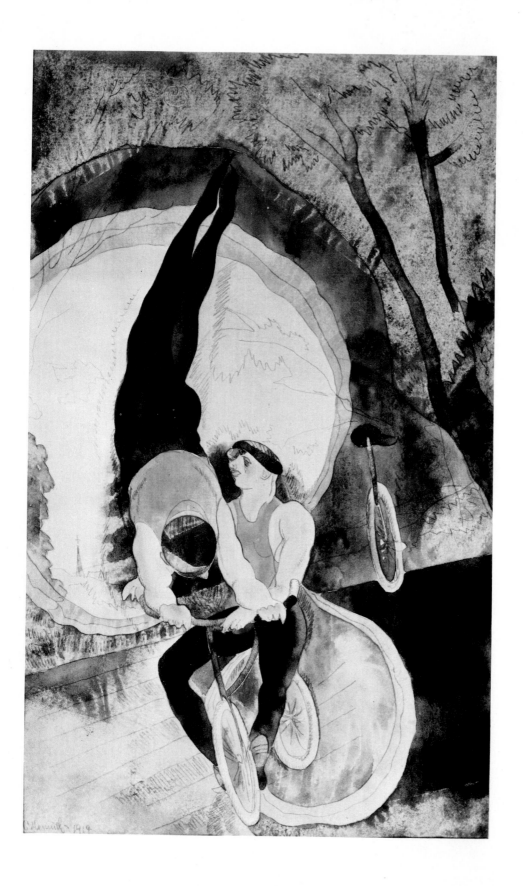

CHARLES

Demuth

BY ANDREW CARNDUFF RITCHIE

REPRINT EDITION PUBLISHED FOR
THE MUSEUM OF MODERN ART

ARNO PRESS
NEW YORK 1980

Reprint Edition 1980 by Arno Press Inc.

Charles Demuth was originally published in 1950 by The Museum of Modern Art.
The color plates have been reproduced in black and white for this edition.
Copyright © 1950 by The Museum of Modern Art. All rights reserved.
Manufactured in the United States of America.

Library of Congress Cataloging in Publication Data

New York (City). Museum of Modern Art.
　　Charles Demuth.

　　(The Museum of Modern Art reprints)
　　Reprint of the ed. published by the Museum of Modern Art, New York.
　　Bibliography, by Anne Bollmann: p.
　　Includes index.
　　1. Demuth, Charles, 1883-1935. I. Ritchie, Andrew Carnduff. II. Demuth, Charles, 1883-1935. III. Series: Museum of Modern Art reprints.
ND237.D36N4　1980　　　　　　　759.13　　　　　　　79-25976
ISBN 0-405-12890-8

CONTENTS

Color Plates

ACKNOWLEDGMENTS

On behalf of the President and Trustees of The Museum of Modern Art the director of the exhibition wishes to thank the collectors, museums and dealers whose generosity in lending has made the exhibition possible. Particular thanks are due to Robert E. Locher, life-long friend of Demuth, and Mr. Locher's associate Richard Weyand, who, with extraordinary generosity, made available to me all their photographs, notes, and memorabilia concerning Demuth for use in this book. I am also extremely grateful to Dr. Albert C. Barnes who very kindly permitted me to study the outstanding group of Demuth watercolors and temperas owned by The Barnes Foundation and for his permission to publish many of them here for the first time. For valuable information about Demuth I wish also to thank the following friends of the artist: Louis Bouché, Marcel Duchamp, Miss Elaine Freeman, Miss Antoinette Kraushaar, Miss Georgia O'Keeffe, Mrs. B. Lazo Steinman, Miss Ettie Stettheimer and Carl Van Vechten. Finally, for advice and assistance in preparing the exhibition and the catalogue, I am grateful to Miss Alice Bacon, Miss Margaret Miller, Alfred H. Barr, Jr., and S. Laine Faison, Jr.

ANDREW CARNDUFF RITCHIE
Director of the Exhibition

CHARLES Demuth

Elegant, witty, frivolous, dandified, shy, kind, gentle, amusing — Charles Demuth, by all accounts, was all of these things. In the years before and during World War I when his fellow Americans felt that their country was progressing with gigantic bounds ahead of all others, at least in material wealth, Demuth with many another artist sought escape from what he considered was the stifling vulgarity and self-satisfaction to be found on all sides of him. As a fellow student of Demuth's, Rita Wellman, has described it: "When we were very young, we were very old. We were all bored with life: knew everything there was to know, and only condescended to give our time and talents to painting because it seemed to our jaded spirits the one respectable calling left." Henry James, that earlier expatriate, whom Demuth came to admire — and to illustrate profoundly — had felt the same barren wind on these shores and had fled to an older but, to him, a spiritually warmer climate. James had settled in England, a land he found curiously congenial to write in, as opposed to France, when by contrast Paris was drawing young English painters and writers to her to escape the dead weight of Victorian philistinism.

The pattern was more or less the same in both Britain and America. The

5

The Demuth garden, Lancaster, Pa.

rush of industrial expansion undermined or vulgarized any traditional taste for the arts. Ruskin might thunder and Morris fulminate but there was no stopping the course of events. In the younger United States, with a less established tradition, particularly in the visual arts, the sensitive spirit felt even more smothered than in England by the atmosphere of complacency generated by material success. So John Marin, following in Whistler's footsteps, escaped early to Europe. And after the turn of the century he was followed by such men as Alfred Maurer, Max Weber, Arthur Dove, Charles Demuth and others, some of whom finally returned to struggle for the acceptance of what is now called modern art. Some of them knew it — Demuth was one — some didn't, but what they actually desired was "Art for Art's sake." Some would have scorned the phrase, and still do, as a reflection of a decadent, *fin-de-siècle* attitude. Nevertheless, in their determination to paint as they pleased, whatever the social or economic consequences, the modernist crusaders were related to the esthetes, however different their motivation.

Demuth was an esthete. Perhaps because he was always in comfortable financial circumstances and probably because he led a quite sheltered existence during his childhood in Lancaster — his health was delicate and he was also lame — he never felt called upon to battle for any "cause." Furthermore, his pictures seem to have sold moderately well from the beginning and this in itself saved him from any possible embitterment — if he had been of a nature to feel bitterness. I do not mean to suggest he was a creature of sweetness and light. No one was more worldly than he. He had the typical esthete's love of good clothes, good food and drink and gay company. But like all great esthetes there was some iron beneath his dandified exterior and when he had enjoyed the fleshpots sufficiently, in New York or Paris, his favorite haunts, he would return to his home in Lancaster and apply himself to his painting. Watercolor was his favorite medium; it fitted his exquisite tastes, and with it he expressed with extraordinary precision and delicacy of perception the things that interested him most. Flowers endlessly fascinated him. They were in the family, as it were. His mother kept a luxuriant Victorian garden which is still the glory of the Demuth

6

house in Lancaster; his grandmother Caroline and his aunt Louisa were sensitive amateur flower painters (pp. 8 and 9). Vaudeville and theatrical reviews he loved, and in numerous watercolors he does for the New York night club and music hall stage of his day what Lautrec did for the Paris circus of the 90's. From the back door of his home in Lancaster he had an intimate view of the Evangelical Lutheran Church of the Holy Trinity with one of the finest Wren-inspired colonial towers in America and with this imprint on his childhood eye he later came to paint with elegant affection not only this spire but the trim roofs and towers of other colonial buildings in New England and Bermuda. And against this background of classical neatness and refinement he wittily pointed up the encroachments of industrial chimneys and metal watertanks. Finally, he illustrated, though not for publication, a number of stories and plays. The best of these illustrations are, without exaggeration, as fine as anything of the kind ever done in this country.

Here, then, is an artist who has left us as rich and varied a mine of subject matter as any modern American I can think of. Yet all of it is of a piece and in all of it one can trace equally the growth of his personal style and the influences that helped to form it.

He was born in Lancaster, Pennsylvania, in 1883. His family, German in origin, settled in Lancaster in the 18th century. There they established what proved to be a profitable tobacco business which is still in existence today and is still owned by a member of the Demuth family. It is now the oldest business of its kind in this country. Several of Demuth's relatives, in addition to the grandmother and aunt mentioned above, were amateur artists in a modest way and his father, Ferdinand, was a good amateur photographer (below). Perhaps because of this background of art interest, and perhaps for reasons of health, Demuth's parents were sympathetic to his early attempts at drawing and painting and made no attempt to make him follow the family business.

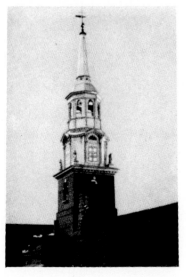

Church of the Holy Trinity, Lancaster, Pa.
Photograph by Ferdinand A. Demuth (d. 1911),
father of the artist. Taken by moonlight,
one hour exposure.

His art education began at the School of Industrial Art in Philadelphia, prior to 1905. In the latter year, at the age of twenty-two, he entered the Pennsylvania Academy of the Fine Arts and, like Marin before him, studied under that inspiring teacher Thomas Anschutz. He interrupted his study in Philadelphia in 1907 to spend about a year in Paris. After completion of his courses at the Pennsylvania Academy in 1910 we know little about him until 1912 when he again returned to Paris for further study at the Académie Colarossi and Julien's, remaining there off and on until 1914.

He must have destroyed almost all of his student work and what little remains from the years between 1908 and 1912 indicates mainly his interest in figure drawing. Two watercolors, one of a studio interior (p. 20) and one of a music hall scene may possibly date from his Paris visit of 1907. They have a breadth and force of brushwork and color that probably reflect direct contact with the *fauve* revolution which was then at its height in Paris, under Matisse's leadership. The few other crayon or pencil drawings from these years are notable for the Steinlen-like strength and life of their line and the early facility they show in catching dramatic gesture and facial expression (p. 19). By 1912 his figure drawing becomes noticeably more elegant and fluent (p. 22), heightened by tinted washes in a Rodinesque manner.[1] At the same time he did some landscapes in watercolor and in oils. The few of the latter I have seen are labored and dull (he never seems to have been entirely comfortable in this medium although he returns to it, together with tempera, in later life). The watercolor landscapes, those he submitted to the Pennsylvania Academy exhibitions in 1912 (p. 21) and 1913 and some he did in 1914 and 1915 (p. 23) show clearly the inspiration of Marin, in particular, and in general the expressionist freedom of brushwork and space-defining color inherited from the *fauves*, particularly Matisse, and eventually Cézanne.

These early landscapes of Demuth's are, I feel, little more than dexterous

Watercolor (19th century) by Louisa Demuth, the artist's aunt.

Watercolor (19th century) by Caroline Demuth, the artist's grandmother.

exercises. As observations of nature they lack any deep conviction. In 1915, however, he applies all his acquired technical mastery to material of great interest to him — flower pieces, acrobatic and vaudeville turns, café and bar scenes. In this first flood of mature work, at the age of thirty-two, Demuth definitely "arrives" as an artist. The intervening years between 1907 and 1915 were spent assimilating much that was to be learned from the *avant garde* in Paris, both as to expressionist freedom of color and cubist analysis of form. The Armory Show of 1913 had stirred the artist and public alike to a frenzy of partisanship, and it undoubtedly helped prepare the way for a partial acceptance of Demuth's watercolors, along with other experimental work. The Daniel Gallery opened in New York about this time to sponsor a group of the new artists, Demuth among them. Stieglitz' famous first showings of modern art in New York at 291 Fifth Avenue had led the way, and Demuth was later to join the Stieglitz "stable" and enjoy the enthusiastic approbation of that master of promotion. And finally Henry McBride, the then recently installed art critic on the *New York Sun,* lent his increasingly important voice to the encouragement of modern art — with Demuth one of his prime favorites. Under these hopeful auspices, whether he needed such encouragement or no, Demuth began after 1915 to produce a steady stream of increasingly brilliant work. The next five years, until 1920 when he was discovered to be suffering from diabetes, he was at the height of his powers.

THE FLOWER PIECES

Let us look first of all at the flower pieces. In a 1915 watercolor, a bouquet of straw flowers on a table (p. 24), the first thing I think one notices is how marvelously Demuth makes use of the white of the paper — as Cézanne had done before him — to define space and volume. The design is first conceived in pencil and the line is wedded to the color washes. How infinitely varied the color areas are in texture and density, with every apparent acci-

9

dent of blotting and overlapping of tones carefully controlled! The crystalline shimmer of the darks and the gradations of tone from dark to light describe the forms of the flowers in a space which seems to breathe. In some mysterious way the whole effect is one of sinister suggestion — *fleurs du mal,* one feels, not the innocent blossoms one was led to expect. A few other flower pieces which I believe must be dated 1915 (for example, p. 26) while they can hardly be described as sinister, explode, as it were, into space. Here, as in a number of the 1915 landscapes, Demuth dispenses with any pencil drawing and achieves his effects by violent slashings of whites and darks set off against a washed and blotted background. Finally, in both types of these first flower pieces there is a noticeable filling out of the whole design from edge to edge of the paper (p. 25). In later years, Demuth increases the spatial recession of his flower pieces (this is true of many of his later landscapes also) by fading out the edges of the composition. But above all it is his astonishing perception of the form and character peculiar to such a wide variety of flowers that impresses one most. He perceives in their individual structure and shape the gestures and features which reveal the personality of a cyclamen, a rose, a poppy or a daisy. About 1928, however, a curious inhibited tightness, as in a botanical drawing, characterizes many of his flower designs. One is left with a feeling that in some of these final pieces, while the hand of the artist has not lost its cunning, his passion for the flower is in some way spent. The advancing progress of the disease, diabetes, from which he died, may explain this change in approach.

FIGURE PIECES: VAUDEVILLE AND BOOK ILLUSTRATIONS

If Demuth's greatest flower pieces have often a disturbingly sinister quality, many of the figure pieces have even more explicit suggestions of decadence, not to say evil, about them. Whether Demuth consciously thought of his acrobats and vaudeville performers in this light I don't know. Certainly the impression many of them leave on me is not one of light-hearted gaiety. The features of the performers are too inane, in many instances, and the acrobats' contortions, while they may present Demuth with some of his most striking compositions, are often in themselves uncomfortably ridiculous. Be that as it may, in the best of these vaudeville or acrobat pieces Demuth's draughtsmanship, his line, like Pascin's, vibrating like a living nerve, has seldom been surpassed. As in the flower pieces, the under-drawing is in pencil. The superimposed washes of color, with a liberal use of the white of the paper, describe the spaces and the volumes, and determine the mood of the whole. A noticeable feature of many of these theater pieces is Demuth's penchant for striking contrasts of lights and darks; the extraordinary richness and varying density of his blacks impresses one above all. The stage spotlight and the black and white evening dress of many of his performers served him well in this respect.

While these night-life scenes hold an endless fascination not only in themselves but as records of a phase of American life during and immediately

after World War I, Demuth's most important figure pieces are his illustrations for stories and plays.

During 1915 and 1916 he made twelve illustrations for Zola's *Nana* (previous accounts give a total of six; twelve can now definitely be identified) and one for Zola's *L'Assommoir*. In 1918 he made five illustrations for James's *The Turn of the Screw* (an additional watercolor of a boy and girl, dated 1912, is thought to have been intended as a frontispiece for this story) and seven for the German dramatist Frank Wedekind's *Erdgeist* and its sequel, *Pandora's Box;* Demuth treats both plays as one, and numbers the acts accordingly. I have been able to identify certainly only four of these illustrations, two for *Erdgeist* and two for *Pandora's Box;* a fifth known watercolor,[2] differing in important essentials from these four, is said to be for *Erdgeist*. In 1919 he produced three illustrations for James's *The Beast in the Jungle;* in addition, two preliminary studies for one of these watercolors can now be identified. During the years 1915 to 1919 he made one illustration for Balzac's *The Girl with the Golden Eyes,* one for Walter Pater's *A Prince of Court Painters* (I have not been able to trace either of these and no reproductions exist) and one watercolor for Poe's *The Masque of the Red Death,* which is now identified. Finally, he made one watercolor in 1930 for a little known story by Robert McAlmon, entitled *Distinguished Air*.[3]

The *Nana* illustrations are apparently the first and also the most extensive series Demuth executed. Technically, this series displays the full range of Demuth's extraordinary mastery of line and color. In one or two instances there are clear echoes of Rodin's (p. 45) and Lautrec's (p. 38) inspiration. Lautrec we know he admired, and Rodin's drawings he must have studied also. His other known admirations, Rubens, Greco, Watteau, Fragonard, Blake and Beardsley do not appear as overt influences in these or any of the other illustrations, so far as I can see, with the possible exception of the one for Poe's *The Masque of the Red Death,* which may owe something to Beardsley. Aside from these slight borrowings, however, the style of these drawings is Demuth's own. The combination of pencil drawing and watercolor wash we have already noted in the vaudeville and circus pieces. Here his technique is displayed in all its variety, now delicate and subtly suggestive (pp. 36, 43, and 44), now savage and foreboding (pp. 41, 42, 46, and 47), as the mood of the scene demands.

Demuth makes no attempt to be literal in his interpretation of many of the *Nana* scenes and except in one watercolor (p. 38), he provides no written clues, as he does in his James and Wedekind pictures, to particular passages in the novel. In fact, after a very careful reading of the text, I have come to the conclusion that many of the *Nana* drawings were done from memory and that occasionally two or more of Zola's scenes may have become fused in Demuth's recollection of them. This seems to be true of the fourth and possibly the ninth, tenth and eleventh illustrations (pp. 39 and 43-46), and the passages of text I have associated with these particular drawings must be

read with this fact in mind. In any case, Demuth apparently never intended these or any of his other illustrations for publication. They were done as private interpretations of his own reading of the various texts, and he therefore felt under no obligation to please a literal-minded publisher or reader. It is, in fact, Demuth's lack of literalness that raises all of his illustrations to a plane parallel with, and not subsidiary to, the stories and plays in question. His was too independent an imagination to be bound by an author's actual description of a scene. Like Delacroix's inspirations drawn from Scott's novels, or Berlioz' interpretations of Byron's poetry, Demuth sought to recreate stories and plays in his own medium and to give them a new and quite different life, conceived in visual terms.

Demuth's next three series of illustrations, those for Wedekind's plays and for James's two short stories present an extreme contrast in subject matter. Nothing could be further removed from James's fine-spun tales of horror than Wedekind's hysterical, expressionistic theater. Yet Demuth encompasses the spirit of both authors to an amazing degree. The violent, puppet-like posturings of Wedekind's neurotic characters are captured completely. The comic-strip balloons enclosing each speech give an added touch of weirdness to the scenes. And as for the James illustrations, they have rightly been called Demuth's masterpieces. Rarely, if ever, has the mood and atmosphere of two stories been more perfectly translated into visual terms. Demuth's affinity for James must have been extremely close to arrive at such sympathetic understanding.

The stories and plays that appealed to Demuth for illustration are very significant with reference both to himself and his time. Almost without exception, they deal with sex as a symbol of social degeneracy. *Nana* is the classic story of the courtesan who, in driving men to self-destruction, destroys the moral and economic supports of society. Wedekind's Lulu in *Erdgeist* and *Pandora's Box*[4] is a kind of German version of Nana — the courtesan wife who kills, or drives to suicide, one husband after another. Both represent the raw vitality of the lowly-born female who uses her exuberant physical powers to make a mockery of her sophisticated, weakling lovers. James's horror stories are extremely subtle expositions of sexual perversion or dislocation. Poe's *The Masque of the Red Death,* while it has no overt sexual implications, is certainly a melodramatic study in wanton degeneracy, with fevered sexual undertones.[5]

Looked at from a personal standpoint, Demuth's preoccupation with these illustrations of the morbid and the perverse undoubtedly reflects a deep unbalance and disquiet in his own nature. One must remember that, like Lautrec, though not to the same degree, he was lame, and this abnormality must have haunted him all his life. In addition, he was never physically robust. Sheltered as a child and as a man by an extraordinarily robust mother, his frequent escapes to the bohemian worlds of Paris, New York and Provincetown are a further indication of the psychological tensions under

which he lived and which are reflected in his painting and most of all in his illustrations.

But these illustrations, together with his acrobat and vaudeville characters, and the foreboding quality of many of his flower pieces, reflect much more than a personal morbidity. Were they merely private records of a complex personality their interest would be limited indeed. Demuth's watercolors, particularly those done during the years 1915 to 1919, must be seen as distillations of that period of esthetic bohemianism that flowered during the first two decades of this century and whose roots were in Paris, London and Berlin. Here is their supreme interest. No other American has given us by implication so sensitive and so subtle an account of the cynicism and disillusionment that marked the years before and during World War I, a malaise which finally erupted into the dizzy abandon of the so-called jazz age.

EARLY LANDSCAPES: REACTION TO CUBISM

One of the most important sides of Demuth is his reaction to the outstanding art movement of his time — and probably of our century — cubism. During the years 1912 to 1914, when he was in Paris, the cubist revolution reached an intensity of expression and discovery unequalled before or since. Braque and Picasso had led the way in the exploration of this new vision of form and space. Their analysis of forms in terms, not of the fixed perspective of the traditional point of view, but of many points of view seen simultaneously, was avidly followed and developed by such devotees as Marcel Duchamp, Albert Gleizes, Jean Metzinger and Juan Gris, to name some of the most outstanding. A somewhat mystical account of cubist principles by Gleizes and Metzinger was published in French in 1912. An English translation was published in 1913. Gleizes himself was in New York from 1915 to 1916. Whether Demuth met him I don't know, but one may presume he had read his book. Duchamp came to New York in 1915 and became a close friend of Demuth's. From his own observations in Paris, from his reading, and his personal association with one of the leading cubists, Demuth was in an unusual position as an American to understand what the whole movement was about. Furthermore, something of Duchamp's nihilistic, even cynical approach to cubism may have appealed to Demuth's anarchic bohemianism as reflected in the illustrations of this same time. At all events, in 1916 we find him adapting some of the cubist formulas, in a very personal way, to architectural landscapes. He made a visit to Bermuda at this time and many of his first cubist landscapes are derived from scenes on that island. In these first essays in the new manner Demuth emphasizes the decorative possibilities of the cubist style. By 1915, the full fervor of the cubist intellectual analysis of form had passed, in any case, and a more sensuous, even decorative, development is in evidence even in the paintings of the leaders like Picasso and Braque. The trim, clean lines of Bermuda's colonial buildings clearly appealed to Demuth, familiar as he was from

childhood with the fine 18th century church next door to his home in Lancaster. And this interest in colonial architecture, whether it was to be found in New England or in his native town remains a prominent feature in his landscapes, at least until 1920. The extremely delicate color washes of these early architectural landscapes, particularly the Bermuda scenes, which contribute so much to their fastidious, decorative air, may derive in part from Demuth's known interest in Japanese prints. He actually helped organize an exhibition of "Living Japanese Prints" in 1914 in Provincetown.

Demuth's particular adaptation of cubism, his use of ray-like shafts of diagonals, forming a kind of net to support the motif of his design, has been compared with Feininger's similar technique. Surely there is a strong parallel between Demuth's *Schooner* of 1917 (p. 65) and Feininger's *Side-Wheeler*[6] of 1913. Whether this similarity is a purely accidental one there is no way of knowing since we don't know whether Demuth had seen any of Feininger's paintings at this time. A stronger influence, I think, can be detected as stemming from the landscapes of Metzinger, Gleizes and Léger, dating from about 1911 to 1916. Demuth's practice in 1917 of setting his straight-edge-drawn architecture within an irregular, curvilinear frame of tree branches (p. 63) appears to be related to a similar compositional device in a Metzinger landscape of 1911[7] or a Léger landscape of 1914.[8] Likewise, Demuth's characteristic use of intersected diagonals in contrasting light and dark shafts (pp. 66 and 68) should be compared with Gleizes's *Brooklyn Bridge* of 1916[9] (which Demuth may have seen in New York). Metzinger's *Harbor* of about 1912,[10] with its overall pattern of masts and sails, its crisscrossing diagonals and its asymmetrical framing of the composition is a striking forerunner of Demuth's view of *Gloucester* (p. 66), and his *Sails* (p. 67), both done in 1919.

LATER LANDSCAPES: COLONIAL AND INDUSTRIAL

It is notable that Demuth uses the familiar watercolor medium in his first cubist landscapes, from 1916 to 1918. About 1919 he turns to tempera and about 1920 to oil. Throughout the '20s and until a year or two before his death, many of his most ambitious landscapes are in oil. Although he continued to use watercolor for his flower pieces and for his late, somewhat chilled, figure pieces of the '30s (p. 88), he appears to have felt that his architectural subjects demanded a larger compass than the watercolor paper provided and a more substantial medium. Probably, also, like most water-colorists, he felt frustrated occasionally by the common critical judgment that, rightly or wrongly, places watercolors in a slighter category than oils. Some of his oils, I feel, incline to be labored or overly meticulous in execution. His voice, as it were, is not entirely comfortable in this new range of textures and sonorities and while he always had an innate sense of design, the effort to retain his niceties of control on a larger scale put him to a considerable strain. At his best, however, he did strike out a number of impressive compositions, the best, I think, in tempera (for example, *End of the Parade, Coatsville, Pa.,* p. 70 and *After Sir Christopher Wren,* p. 71) and

14

a few oils (for example *Paquebot Paris,* p. 74, and the monumental *My Egypt,* p. 84).

Demuth makes one significant distinction between tempera and oil. He uses the first almost exclusively for his favorite colonial architecture subjects and the second for almost all of his industrial scenes. In the colonial architecture temperas it will be observed that, with a few exceptions, he continues his decorative practice of "floating" the composition in an indeterminate space, an effect he achieves by fading out the edges of his forms or linear patterns towards the frame. In many of the oils of industrial or urban scenes, on the other hand, he apparently feels compelled to block out the whole composition to the edge of the canvas. The effect produced is, for Demuth, one of considerable weight and severity, undoubtedly to express his reaction to the impersonal, mechanical contours of 20th century industrial architecture.

These industrial pictures of the '20s are a new departure for Demuth. Although in his depiction of such subject matter his name has been associated with Charles Sheeler's and Preston Dickinson's, the so-called "Immaculates," his treatment of the industrial scene is different from theirs. Like them, his approach to industry has in it something of the intellectual's newly discovered respect for the precise shapes, the clear logic of the factory building and the machine. But with Demuth this admiration is curiously mixed with the esthete-bohemian's disdain of industry. Like some of the cubists and the dadaists he was both attracted and repelled by the modern machine world. This ambivalent attitude is reflected in many of Demuth's cryptic picture titles. Many of them suggest his lighthearted refusal to be overly impressed by the rising tide of industrial building in the prosperous '20s. Such titles as *"... And the Home of the Brave,"* *Incense of a New Church, Waiting,* *"... After All,"* have a certain kinship with the more wryly ironic titles his friend Duchamp had given many of his pictures. In a related cubist connection (Braque initiated the practice) Demuth uses numbers, letters and broken words in many of his compositions of this time (p. 72). In at least one instance (p. 75) his use of numbers and days of the week is obviously a humorous jibe at business routine.

POSTER PORTRAITS: STILL LIFES

This cubist use of words and letters Demuth applies to a type of picture that is his own invention. They have been called, for want of a better term, poster portraits. All of them are in oil, on canvas or board. They were done to honor a few of his intimate friends — among them Georgia O'Keeffe, Arthur Dove, Marsden Hartley and John Marin. The best, I think, is *"I Saw the Figure 5 in Gold"* (color plate opposite p. 70), a symbolic portrait of Demuth's friend William Carlos Williams, inspired by the first line of one of the latter's poems. The painting called *Longhi on Broadway* is said to refer to Eugene O'Neill.

Finally, there remains to mention a group of fruit still-lifes, all in water-

color, which Demuth executed during the '20s. Side by side with his industrial oils he continued his watercolor paintings of flowers. In the latter there is no indication of Demuth's cubist interests. He apparently felt his flowers were not congenial subjects for cubist compositional invention or fantasy. The fruit pieces, however, do show a gentle cubist overlay in their angular, faceted definition of form and in the interplay of curves and diagonals radiating towards the edges of the paper (p. 76). But in the finest of these still-lifes — the various arrangements of pears (p. 82) — his greatest debt is to the true founder of cubism, Cézanne.

Demuth died in 1935 at the age of fifty-two. Although his working life was fairly short and despite ill health during the last fifteen years, he produced over nine hundred paintings. The best of these, and they are many, are a true reflection of his extraordinarily sensitive and complex personality. He borrowed inspiration from abroad, as we have seen, but what he borrowed he wore lightly and with ease. As he once said: "John Marin and I drew our inspiration from the same source, French modernism. He brought his up in buckets and spilt much along the way. I dipped mine out with a teaspoon, but I never spilled a drop."[11]

<div align="right">A.C.R.</div>

NOTES TO THE TEXT

1. In 1910 he may well have seen the second exhibition of Rodin's drawings presented by Alfred Stieglitz at his Photo-Secession Gallery, 291 Fifth Avenue, New York.

2. Robert E. Locher Collection, Lancaster, Pa.

3. Illustrated *Charles Demuth* by William Murrell. The Whitney Museum of American Art. New York, 1931. P. 16.

4. It is of interest to note that these two plays of Wedekind's first appeared in English translation in the *Glebe* magazine (New York) in 1914 and that a play of Demuth's, *The Azure Adder,* one of his occasional attempts at writing, was published in the same magazine the year previous.

5. Demuth spoke of doing illustrations for Proust's *A la recherche du temps perdu,* for which he would have been peculiarly fitted. Unfortunately his intentions were never realized. In later life when the critic Henry McBride asked him why he did no more figure pieces he said: "I simply haven't the strength."

6. Illustrated *Feininger-Hartley.* The Museum of Modern Art, New York, 1944. P. 22.

7. Illustrated *Kubismus* by Albert Gleizes, Munich, 1928. Pl. 28.

8. *ibid.,* Pl. 21.

9. Illustrated *Cubism and Abstract Art.* The Museum of Modern Art, New York, 1936. Pl. 72.

10. Illustrated *Cubism* by Albert Gleizes and Jean Metzinger. T. Fisher Unwin, London, 1913. p. 87.

11. Quoted by George Biddle, *New York Herald Tribune Book Review,* Nov. 13, 1949. P. 5.

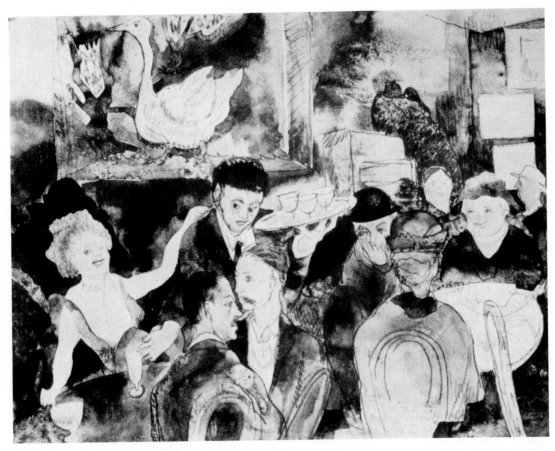

At "The Golden Swan" Sometimes Called "Hell Hole." Self-portrait with Marcel Duchamp. 1919. Watercolor, 8¼ x 10¾". Collection Robert E. Locher, Lancaster, Pa.

A TRIBUTE TO THE ARTIST
BY Marcel Duchamp

The Hell Hole (the "Golden Swan" in the Village), the Baron Wilkins (a café) in Harlem, a costumed ball at Webster Hall, Cafés Brevoort and Lafayette were Demuth's favorite places about 1915-16 and he used to take me along. . . .

He had a curious smile reflecting an incessant curiosity for every manifestation life offered.

An artist worthy of the name, without the pettiness which afflicts most artists; worshipping his inner self without the usual eagerness to be right.

Demuth was also one of the few artists whom all other artists liked as a real friend, a rare case indeed.

His work is a living illustration of the disappearance of a "Monroe Doctrine" applied to Art; for today, art is no more the crop of privileged soils, and Demuth is among the first to have planted the good seed in America.

New York, 1949

17

CHRONOLOGY

1883 Born Lancaster, Pennsylvania, November 8

1887 Leg injury about this time which made him permanently lame

1899 Entered Franklin and Marshall Academy in Lancaster

1901 Graduated from Franklin and Marshall Academy. Entered Drexel Institute, Philadelphia

1905 Entered the Pennsylvania Academy of The Fine Arts in Philadelphia. (Previously he had spent some time at the School of Industrial Art in the latter city.)

1907 First visit to Paris. Visited London and Berlin

1908 Returned from Paris and took up his courses again at the Pennsylvania Academy

1912 Second visit to Paris. Studied at the Académie Colarossi, the Académie Moderne, and Julien's

1914 Returned to the United States. Organized, with Helen Jungerich, exhibition of "Living Japanese Prints" at Provincetown

1915 His first one-man exhibition at the Daniel Gallery, New York

1916 Summer in Provincetown. Fall and winter in Bermuda

1917 Returned from Bermuda. Summer in Gloucester, Mass. and Lancaster

1918 Summer in Gloucester

1920 Discovered to be suffering from diabetes

1921 Third visit to Paris. Sailed and returned on the steamship *Paris* (the subject of one of his oils)

1922 Entered sanitarium at Morristown, N. J. to undergo treatment for diabetes. Later was one of first to receive the newly discovered insulin

1925 Included in seven-man exhibition organized by Alfred Stieglitz at the Anderson Galleries, New York

1930 Summer, Provincetown

1934 Summer, Provincetown

1935 Died Lancaster, October 25

Drawing. 1906 or '07. Conté crayon, 9½ x 7½". Collection
Robert E. Locher, Lancaster, Pa.

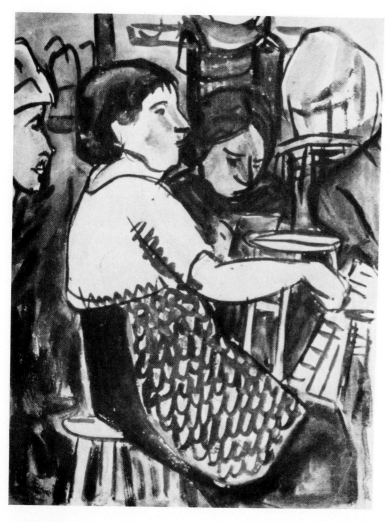

Studio Interior. 1907? Watercolor, 12⅜ x 9½". Collection Robert E.
Locher, Lancaster, Pa.

New Hope, Pennsylvania. 1911 or '12. Watercolor, 8¾ x 11¾". Collection Robert E. Locher, Lancaster, Pa.

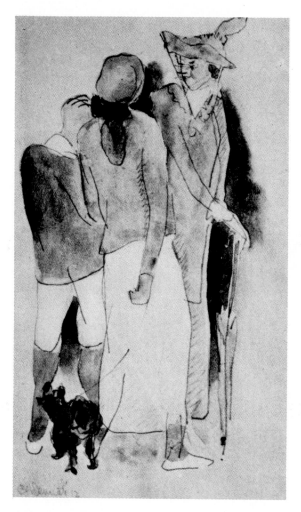

Strolling. 1912. Watercolor, 8½ x 5⅛″. The Museum of Modern Art, gift of Mrs. John D. Rockefeller, Jr.

Right: *Boy and Girl.* Thought to be frontispiece for Henry James's *The Turn of the Screw.* 1912. Watercolor, 8¼ x 5⅛″. Collection Philip Hofer, Rockport, Maine

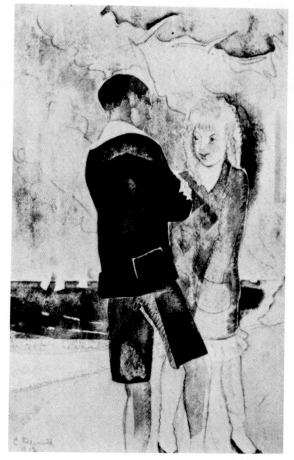

Dunes. 1915. Watercolor, 11⅜ x 16$\frac{1}{16}$″. The Columbus Gallery of Fine Arts, Columbus, Ohio. Ferdinand Howald Collection

Flowers. 1915. Watercolor, 13 x 8″. Collection Louis Bouché, New York

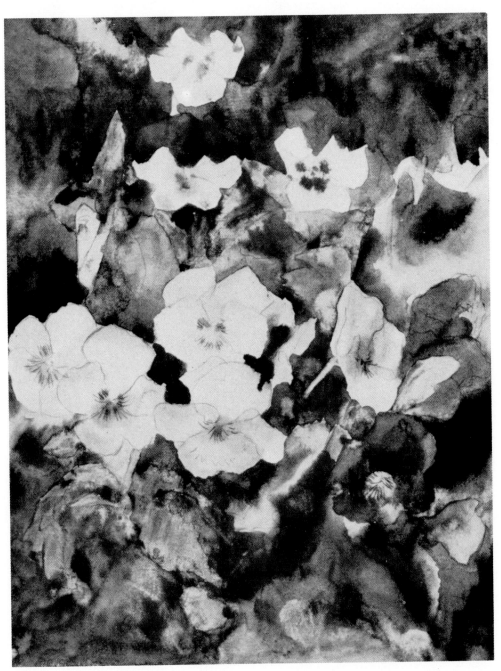

Pansies. 1915. Watercolor, 10¼ x 7¹¹⁄₁₆″. Collection Mrs. Stanley Resor, New York

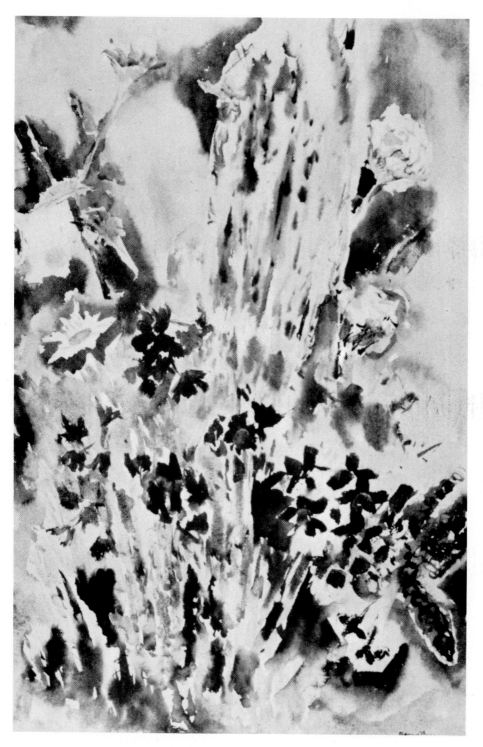

Flower Piece. 1915. Watercolor, 18 x 11½″. Collection Miss Susan W. Street, New York

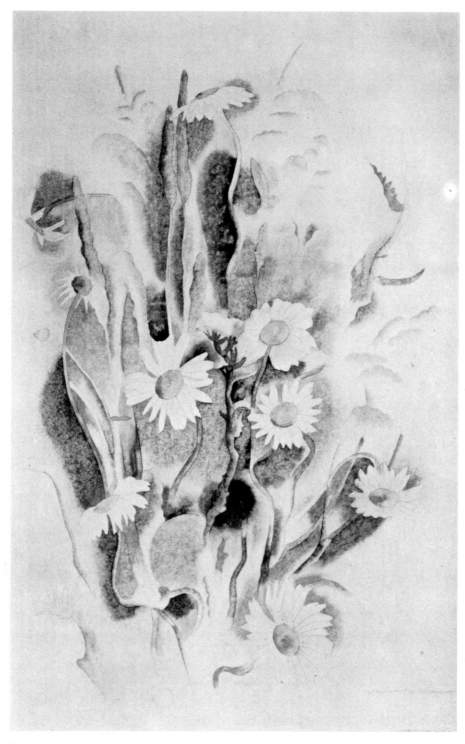

Daisies. 1918. Watercolor, 17½ x 11½″. The Whitney Museum of American Art, New York

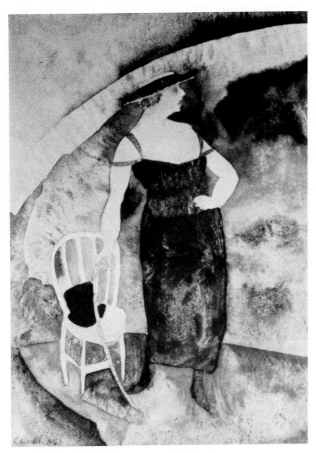

Vaudeville: Woman with Walking Stick. 1916. Watercolor, 11 x 8". The Mullen Collection, Merion, Pa.

Right: *"Many Brave Hearts are Asleep in the Deep . . ."* 1916. Watercolor, 13 x 8". The Mullen Collection, Merion, Pa.

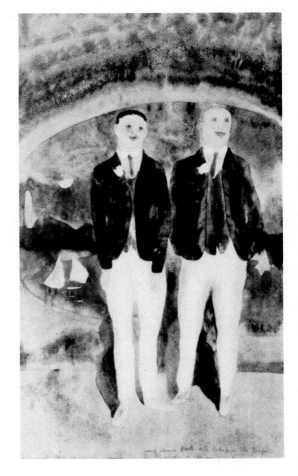

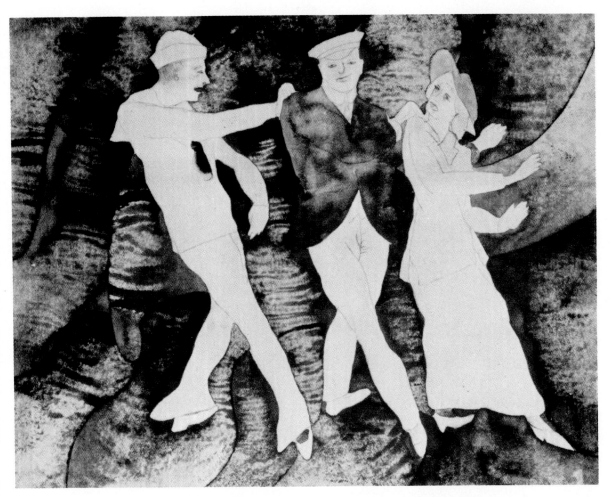

Vaudeville. 1917. Watercolor, 8' x 10⅜". Collection Miss Elaine Freeman, New York

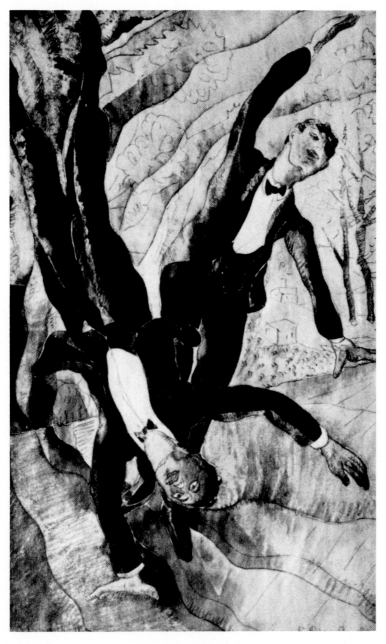

Two Acrobats. 1918. Watercolor, 13 x 7½". Collection Mrs. Edith Gregor Halpert, New York

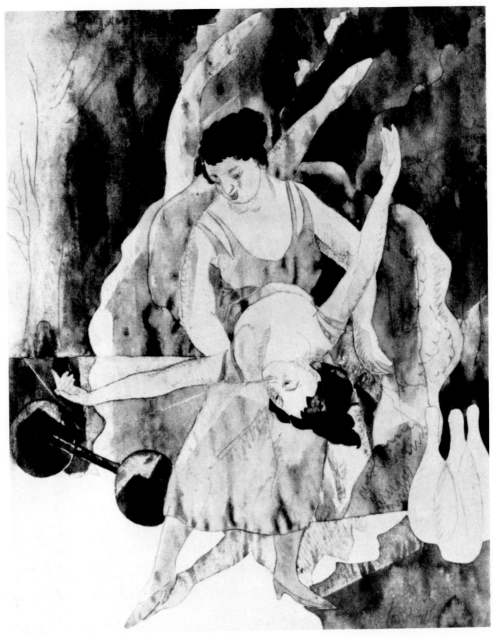

Acrobats. 1918. Watercolor, 10⅞ x 8⅜″. Collection Mrs. Edith Gregor Halpert, New York

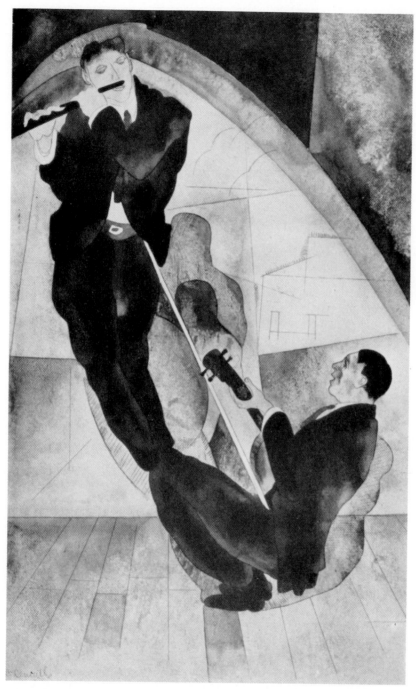

Vaudeville Musicians. 1917. Watercolor, 13 x 8″. The Museum of Modern Art,
Mrs. John D. Rockefeller, Jr. Purchase Fund

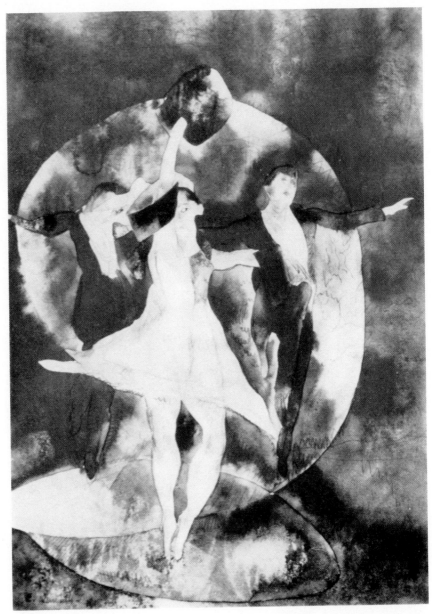

The Green Dancer. 1916. Watercolor, 11 x 8″. Collection Mr. and Mrs. S. S. White III, Ardmore, Pa.

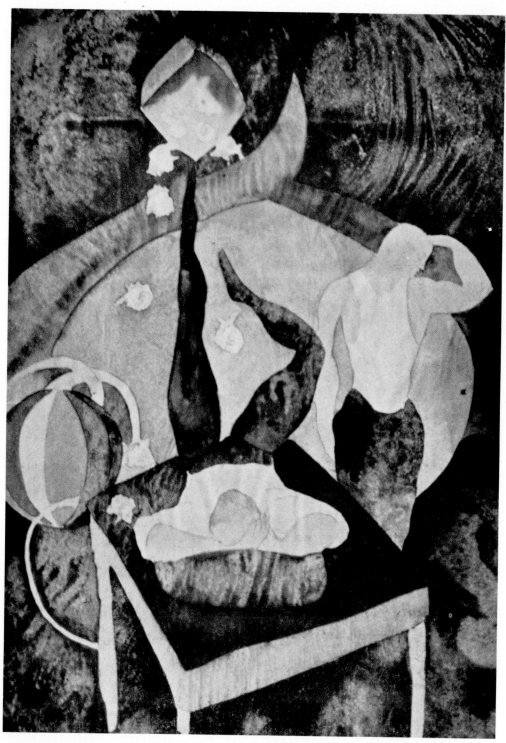

Acrobats. 1916. Watercolor. The Barnes Foundation, Merion, Pa. *Not in the exhibition*

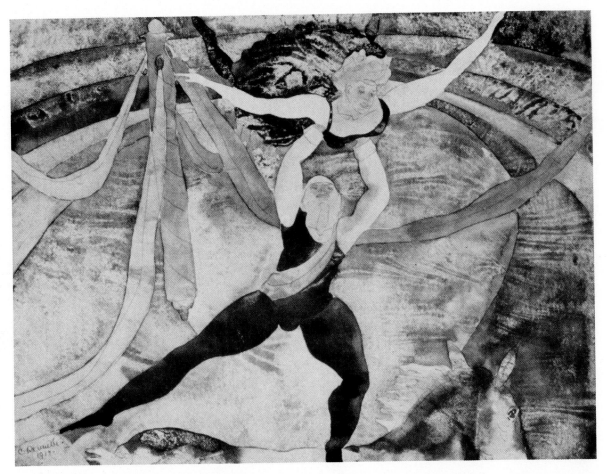

The Circus. 1917. Watercolor, 8 x 10⅝″. The Columbus Gallery of Fine Arts, Columbus, Ohio. Ferdinand Howald Collection

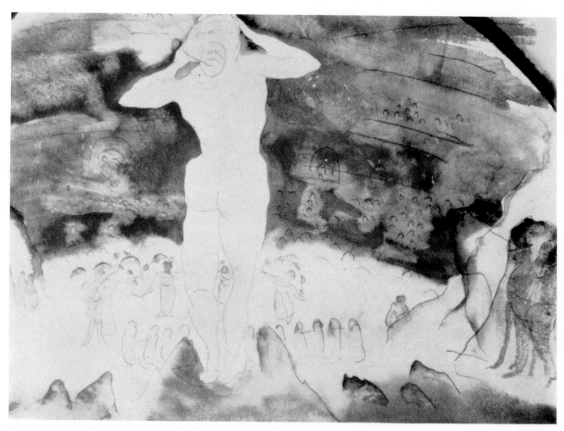

Count Muffat's First View of Nana at the Theater. Illustration no. 1 for Zola's *Nana* (Chapter V), 1915-16. Watercolor, 8½ x 10¾". The Barnes Foundation, Merion, Pa. *Not in the exhibition*

"There was a profound silence, and then a deep sigh and the far-off murmur of a multitude became audible. Every evening when Venus entered in her god-like nakedness the same effect was produced. Then Muffat was seized with a desire to see; he put his eye to a peep-hole. Above and beyond the glowing arc formed by the footlights the dark body of the house seemed full of ruddy vapour, and against this neutral-tinted background, where row upon row of faces struck a pale, uncertain note, Nana stood forth white and vast, so that the boxes from the balcony to the flies were blotted from view. He saw her from behind — noted her swelling hips, her outstretched arms, . . ."

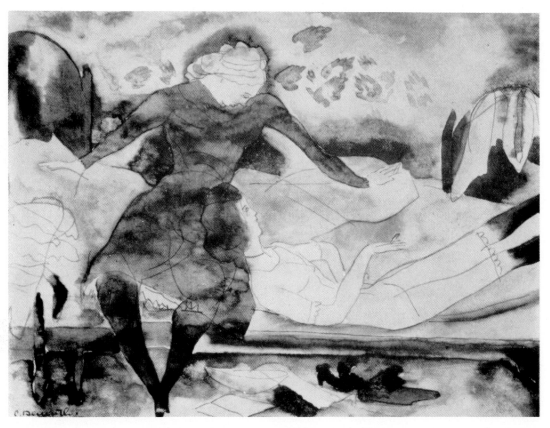

Nana Visiting Her Friend Satin. Illustration no. 2 for Zola's *Nana* (Chapter VIII), 1915. Watercolor, 8½ x 10¾". The Barnes Foundation, Merion, Pa. *Not in the exhibition*

"Nana felt very uncomfortable at Satin's, sitting doing nothing on the untidy bed whilst basins stood about on the floor at her feet, and petticoats which had been bemired last night hung over the backs of arm-chairs and stained them with mud. They had long gossips together and were endlessly confidential, . . ."

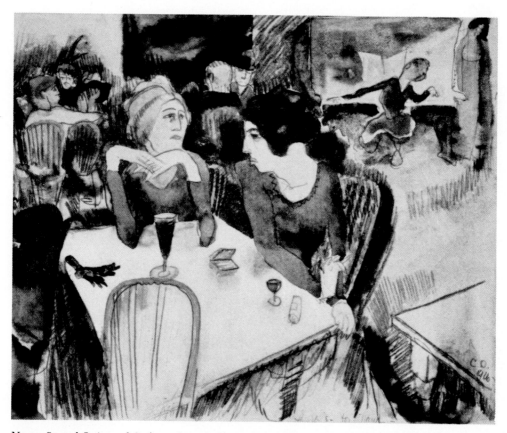

Nana, Seated Left, and Satin at Laure's Restaurant. Illustration no. 3 for Zola's *Nana* (Chapter VIII), 1916. Watercolor, 8½ x 10¾". The Museum of Modern Art, gift of Mrs. John D. Rockefeller, Jr.

"The next day Fontan informed Nana that he was not coming home to dinner, and she went down early to find Satin, with a view to treating her at a restaurant. The choice of the restaurant involved infinite debate. Satin proposed various brewery bars, which Nana thought detestable, and at last persuaded her to dine at Laure's. This was a *table d'hôte* in the Rue des Martyrs, where the dinner cost three francs."

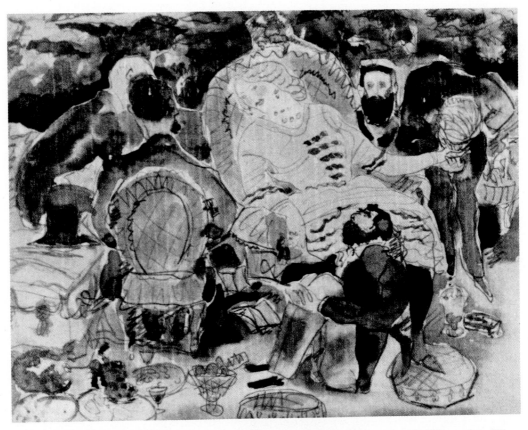

Nana and Her Men. Illustration no. 4 for Zola's *Nana* (Chapter X?), 1915-16. Watercolor, 8½ x 10¾". The Barnes Foundation, Merion, Pa. *Not in the exhibition*

"The room was full of Nana's intimate existence: a pair of gloves, a fallen handkerchief, an open book, lay scattered about, and their owner seemed present in careless attire with that well-known odour of violets, and that species of untidiness which became her in her character of good-natured courtesan, and had such a charming effect among all those rich surroundings."

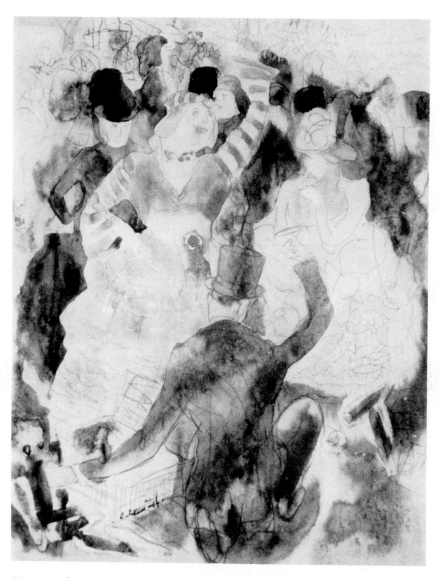

Nana at the Races. Illustration no. 5 for Zola's *Nana* (Chapter XI), 1915-16. Watercolor, 10¾ x 8½". The Barnes Foundation, Merion, Pa. *Not in the exhibition*

"The circle increased, for now La Faloise was filling glasses, and Georges and Philippe were picking up friends. A stealthy impulse was gradually bringing in the whole field. Nana would fling everyone a laughing smile or an amusing phrase. The groups of tipplers were drawing near, and all the champagne scattered over the place was moving in her direction. Soon there was only one noisy crowd, and that was round her landau, where she queened it among outstretched glasses, her yellow hair floating on the breeze, and her snowy face bathed in the sunshine. Then, by way of finishing touch, and to make the other women, who were mad at her triumph, simply perish of envy, she lifted a brimming glass on high, and assumed her old pose as Venus Victrix."

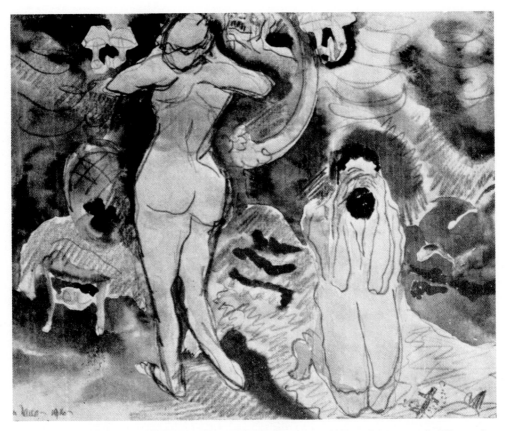

Nana Before the Mirror. Illustration no. 6 for Zola's *Nana* (Chapter XII), 1916. Watercolor, 7⅞ x 9¾″. Collection Richard Weyand, Lancaster, Pa.

"A mirror stopped her, and as of old she lapsed into oblivious contemplation of her nakedness. But the sight of her breast, her waist, and her thighs only doubled her terror, and she ended by feeling with both hands very slowly over the bones of her face.

" 'You're ugly when you're dead,' said she in deliberate tones.

"And she pressed her cheeks, enlarging her eyes and pushing down her jaw, in order to see how she would look. Thus disfigured she turned towards the Count:

" 'Do look! my head'll be quite small, it will!'

"He fancied he saw her in a grave, emaciated by a century of sleep, and he joined his hands and stammered a prayer.

"The joints of his fingers used to crack, and he would repeat without cease these words only: 'My God, my God, my God!' "

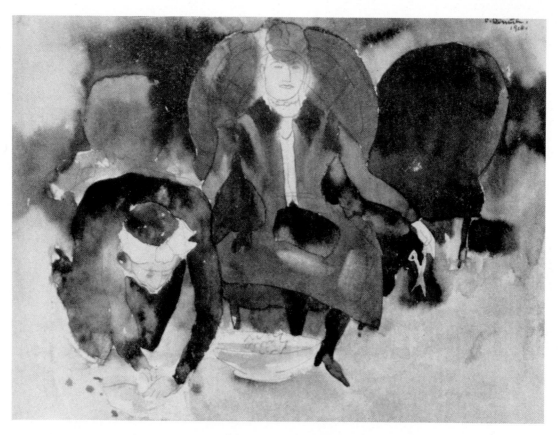

Scene After Georges Stabs Himself With the Scissors. Illustration no. 7 for Zola's *Nana* (Chapter XIII), 1916. Watercolor, 8½ x 10¾″. The Barnes Foundation, Merion, Pa. *Not in the exhibition*

"In her stupefaction Nana had sat down: she still wore her gloves and her hat. The house once more lapsed into heavy silence; the carriage had driven away; and she sat motionless, not knowing what to do next, her head swimming after all she had gone through. A quarter of an hour later, Count Muffat found her thus, but at sight of him she relieved her feelings in an overflowing current of talk. She told him all about the sad incident, repeated the same details twenty times over, picked up the blood-stained scissors in order to imitate Zizi's gesture when he stabbed himself. And above all she nursed the idea of proving her own innocence.

"The lady's maid, having brought a towel and a basin of water out of the dressing-room, had for some moments past been rubbing the carpet in order to remove the blood-stains before they dried."

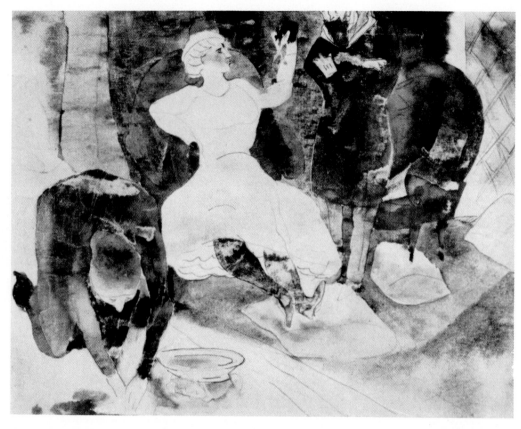

Scene After Georges Stabs Himself With the Scissors (second version). Illustration no. 8 for Zola's
Nana (Chapter XIII), 1915-16. Watercolor, 7¾ x 10". Collection Richard Weyand, Lancaster, Pa.

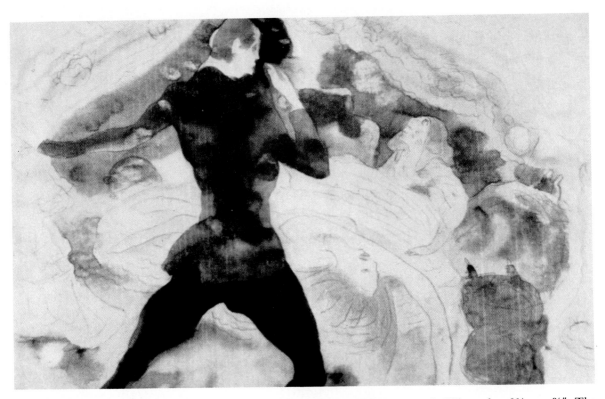

Satin in a Frenzy (?). Illustration no. 9 for Zola's *Nana* (Chapter XIII?), 1915-16. Watercolor, 8½ x 10¾". The Barnes Foundation, Merion, Pa. *Not in the exhibition*

"And Satin, angry at being thrown over every moment, would turn the house topsy-turvy with the most awful scenes.

"On certain days she would very nearly go mad, and would smash everything, wearing herself out in tempests of love and anger, but pretty all the time."

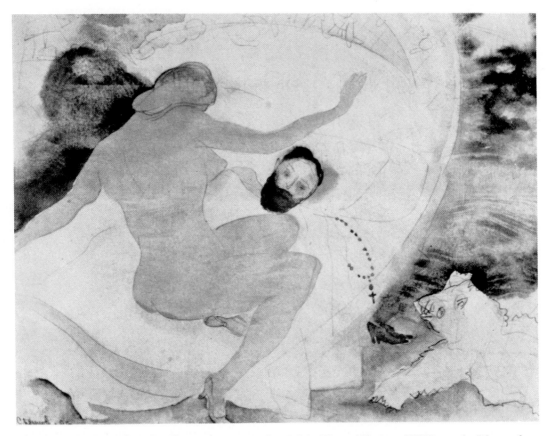

Nana and Count Muffat (?). Illustration no. 10 for Zola's *Nana* (Chapter XIII?), 1916. Watercolor, 8½ x 10¾″. The Barnes Foundation, Merion, Pa. *Not in the exhibition*

"And despite all the struggles of his reason, this bedroom of Nana's always filled him with madness, and he would sink shuddering under the almighty dominion of sex, just as he would swoon before the vast unknown of Heaven."

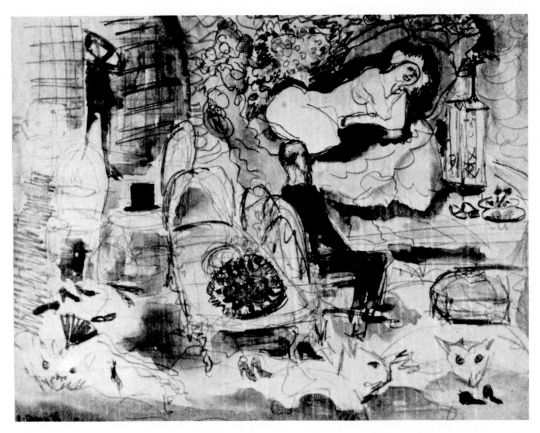

Count Muffat Discovers Nana With the Marquis de Chouard (?). Illustration no. 11 for Zola's *Nana* (Chapter XIII?), 1915. Watercolor, 8½ x 10¾". The Barnes Foundation, Merion, Pa. *Not in the exhibition*

"Then, over against him, there was the gold and silver bed which shone in all the fresh splendour of its chiselled workmanship, a throne this of sufficient extent for Nana to display the outstretched glory of her naked limbs, an altar of Byzantine sumptuousness, worthy of the almighty puissance of Nana's sex, which at this very hour lay nudely displayed there in the religious immodesty befitting an idol of all men's worship."

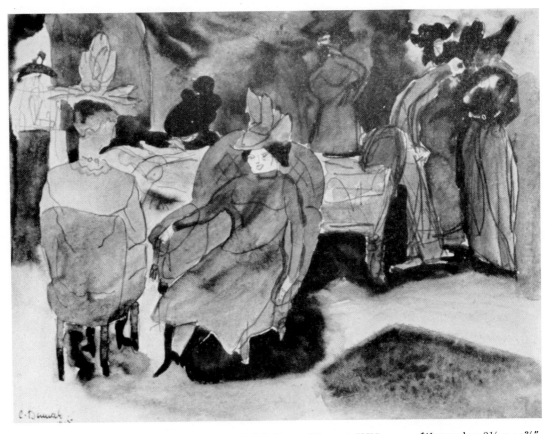

The Death of Nana. Illustration no. 12 for Zola's *Nana* (Chapter XIV), 1915. Watercolor, 8½ x 10¾".
The Barnes Foundation, Merion, Pa. *Not in the exhibition*

". . . there were already five women in the room; Gaga was lying back in the solitary arm-chair, which was a red velvet Voltaire. In front of the fire-place, Simonne and Clarisse were standing talking to Léa de Horn, who was seated, whilst, by the bed to the left of the door, Rose Mignon, perched on the edge of a chest, sat gazing fixedly at the body where it lay hidden in the shadow of the curtains. All the others had their hats and gloves on, and looked as if they were paying a call."

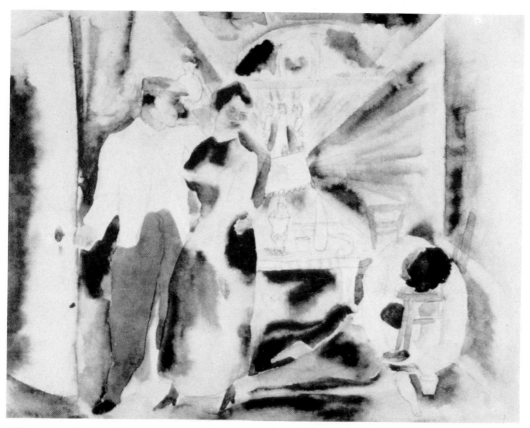

Illustration for Zola's *L'Assommoir*. 1916. Watercolor, 8 x 10½". The Philadelphia Museum of Art, Philadelphia, Pa. A. E. Gallatin Collection.

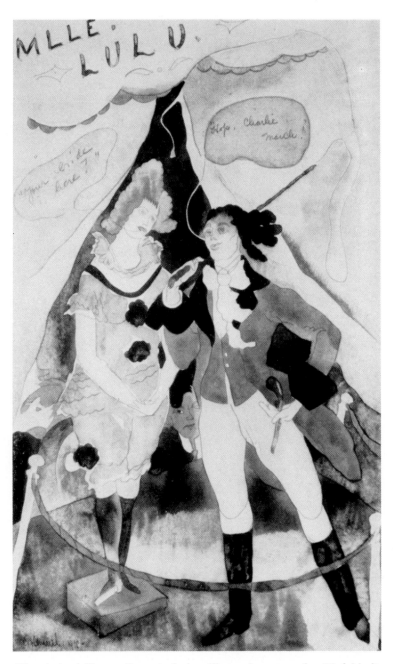

The Animal Tamer Presents Lulu. Illustration no. 1 for Wedekind's *Erdgeist* (Prologue, Act I), 1918. Watercolor, 12$\frac{13}{16}$ x 8". Collection Miss Violette de Mazia, Merion, Pa.

"She was created to incite to sin
To lure, seduce, corrupt, drop poison in, —
To murder, without being once suspected.

"Your bride is here?

"Hop, Charlie, march! Carry her to her cage."

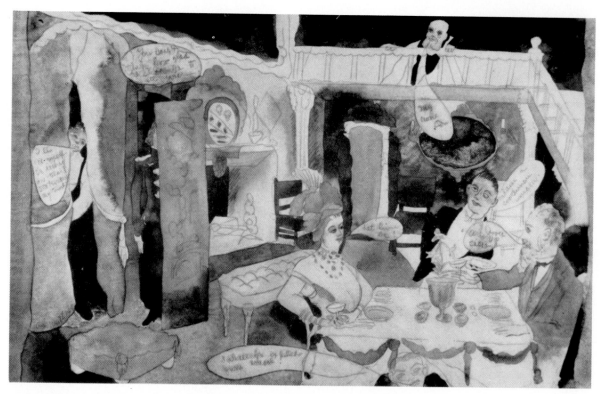

Lulu and Alva Schoen in the Lunch Scene. Illustration no. 2 for Wedekind's *Erdgeist* (Act IV), 1918. Watercolor, 8½ x 10¾". The Barnes Foundation, Merion, Pa. *Not in the exhibition*

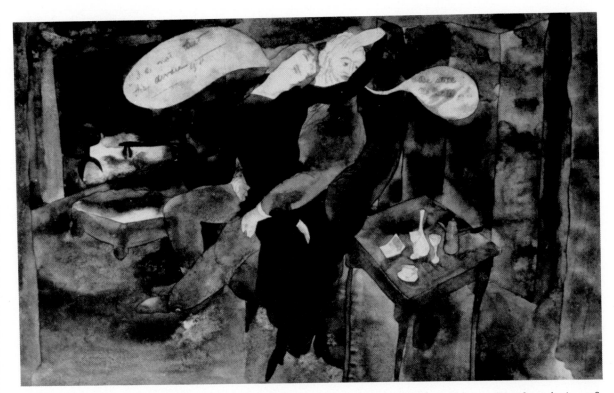

Lulu and Alva Schoen. Illustration no. 1 for Wedekind's *Pandora's Box* (Act I, or V in combined version), 1918. Watercolor, 8½ x 10¾". The Barnes Foundation, Merion, Pa. *Not in the exhibition*

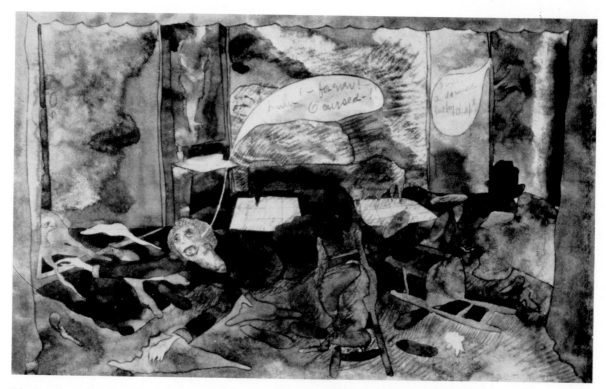

The Death of Countess Geschwitz. Illustration no. 2 for Wedekind's *Pandora's Box* (Act III, or VII in combined version), 1918. Watercolor, 8½ x 10¾". The Barnes Foundation. Merion, Pa. *Not in the exhibition*

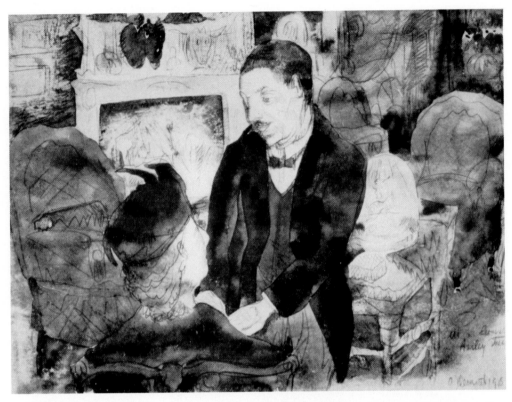

At a House in Harley Street. Illustration no. 1 for Henry James's *The Turn of the Screw* (Prologue), 1918. Watercolor, 8 x 11″. The Museum of Modern Art, gift of Mrs. John D. Rockefeller, Jr.

The guardian interviews the governess about the care of his niece and nephew.

"She conceived him as rich, but as fearfully extravagant — saw him all in a glow of high fashion, of good looks, of expensive habits, of charming ways with women. He had for his own town residence a big house filled with the spoils of travel and the trophies of the chase; but it was to his country home, an old family place in Essex, that he wished her immediately to proceed."

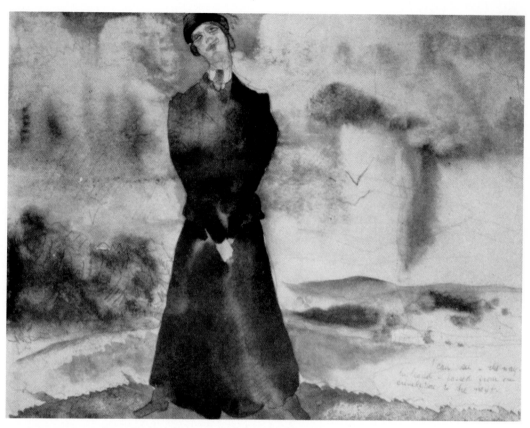

The Governess First Sees the Ghost of Peter Quint. Illustration no. 2 for Henry James's *The Turn of the Screw* (Chapter III), 1918. Watercolor, 8 x 10⅝". Collection Mrs. Frank C. Osborn, Manchester, Vt.

"I can see at this moment the way his hand, as he went, passed from one of the crenelations to the next." (Chapter III)

"There were states of the air, conditions of sound and stillness unspeakable impressions of the *kind* of ministering movement that brought back to me, long enough to catch it, the medium in which, that June evening out of doors, I had had my first sight of Quint." (Chapter XIII)

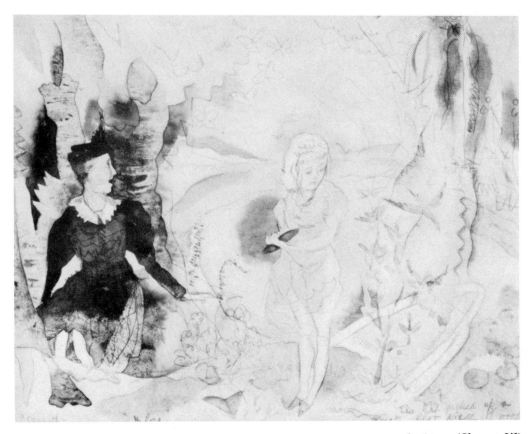

Flora and the Governess. Illustration no. 3 for Henry James's *The Turn of the Screw* (Chapter VI), 1918. Watercolor, 8 x 10⅝". Collection Mrs. Frank C. Osborn, Manchester, Vt.

"She had picked up a small flat piece of wood, which happened to have in it a little hole that had evidently suggested to her the idea of sticking in another fragment that might figure as a mast and make the thing a boat."

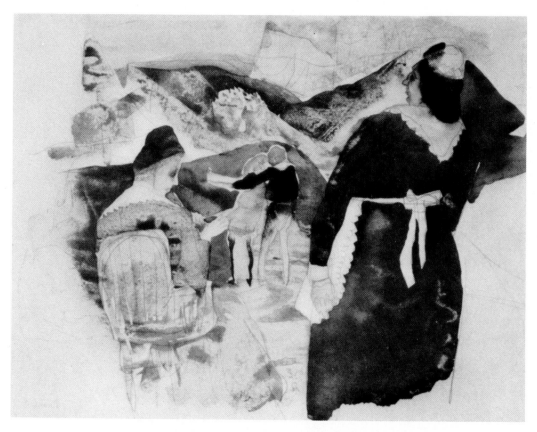

The Governess, Mrs. Grose, and the Children. Illustration no. 4 for Henry James's *The Turn of the Screw* (Chapter XI), 1918. Watercolor, 8 x 10⅜". Collection Mrs. Frank C. Osborn, Manchester, Vt.

"At the hour I now speak of she had joined me, under pressure, on the terrace, where, with the lapse of the season, the afternoon sun was now agreeable; and we sat there together while, before us, at a distance, but within call if we wished, the children strolled to and fro in one of their most manageable moods. They moved slowly, in unison, below us, over the lawn, the boy, as they went, reading aloud from a storybook and passing his arm round his sister to keep her quite in touch."

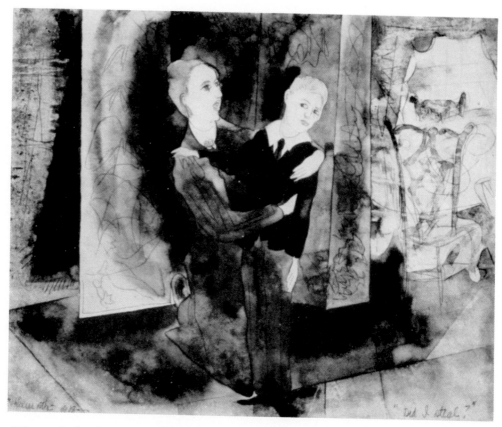

Miles and the Governess. Illustration no. 5 for Henry James's *The Turn of the Screw*
(Chapter XXIV), 1918. Watercolor, 8 x 10¾". Collection Mrs. Frank C. Osborn, Man-
chester, Vt.

" 'Did you take letters? — or other things?'

" 'Other things?' He appeared now to be thinking of something far off and that reached
him only through the pressure of his anxiety. Yet it did reach him. 'Did I *steal*?' "

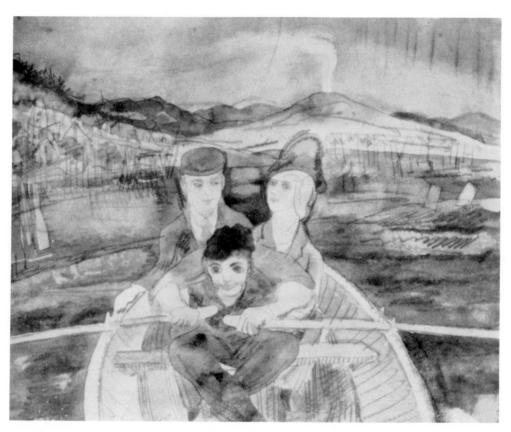

The Boat Ride from Sorrento. Illustration no. 1 for Henry James's *The Beast in the Jungle* (Chapter I), 1919. Watercolor, 8 x 10″. Collection Mrs. Frank C. Osborn, Manchester, Vt.

"You know you told me something that I've never forgotten and that again and again has made me think of you since; it was that tremendously hot day when we went to Sorrento, across the bay, for the breeze. What I allude to was what you said to me, on the way back, as we sat, under the awning of the boat, enjoying the cool. Have you forgotten?"

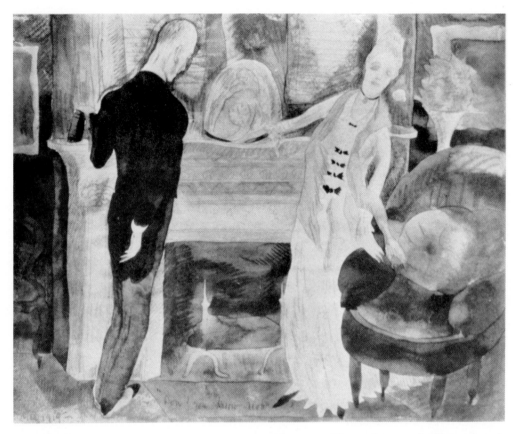

The Revelation Comes to May Bartram in Her Drawing-room. Illustration no. 2 for Henry James's *The Beast in the Jungle* (Chapter IV), 1919. Watercolor, 8 x 10". Collection Mrs. Frank C. Osborn, Manchester, Vt.

"She had touched in her passage a bell near the chimney and had sunk back, strangely pale. 'I'm afraid I'm too ill.'

"'Too ill to tell me?' It sprang up sharp to him, and almost to his lips, the fear that she would die without giving him light. He checked himself in time from so expressing his question, but she answered as if she had heard the words.

"'Don't you know — now?'"

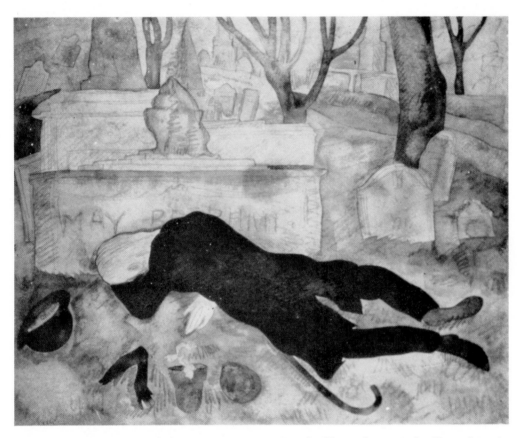

Marcher Receives His Revelation at May Bartram's Tomb. Illustration no. 3 for Henry James's *The Beast in the Jungle* (Chapter VI), 1919. Watercolor, 8 x 10″. Collection Mrs. Frank C. Osborn, Manchester, Vt.

"He saw the Jungle of his life and saw the lurking Beast; then, while he looked, perceived it, as by a stir of the air, rise, huge and hideous, for the leap that was to settle him. His eye darkened — it was close; and, instinctively turning, in his hallucination, to avoid it, he flung himself, on his face, on the tomb."

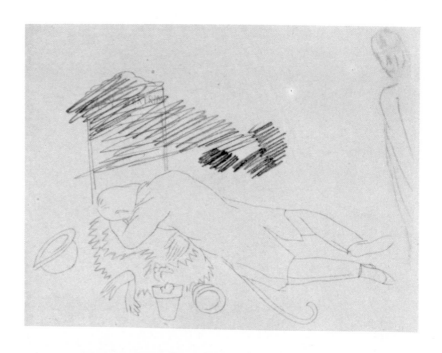

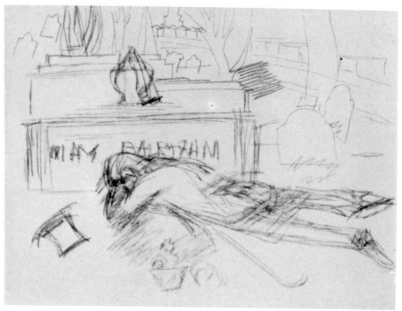

Two Sketches for *Marcher Receives His Revelation at May Bartram's Tomb*, 1919. Pencil, each 8 x 10½". Collection Robert E. Locher, Lancaster, Pa.

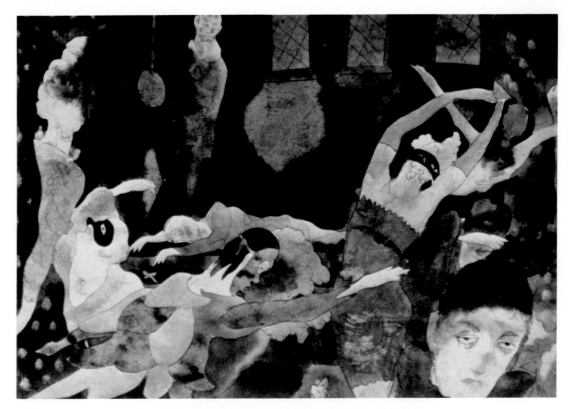

Illustration for Poe's *The Masque of the Red Death*, c. 1918. Watercolor, 8½ x 10¾". The Barnes Foundation, Merion, Pa. *Not in the exhibition*

"And now was acknowledged the presence of the Red Death. He had come like a thief in the night. And one by one dropped the revelers in the blood-bedewed halls of their revel, and died each in the despairing posture of his fall. And the life of the ebony clock went out with that of the last of the gay. And the flames of the tripods expired. And Darkness and Decay and the Red Death held illimitable dominion over all."

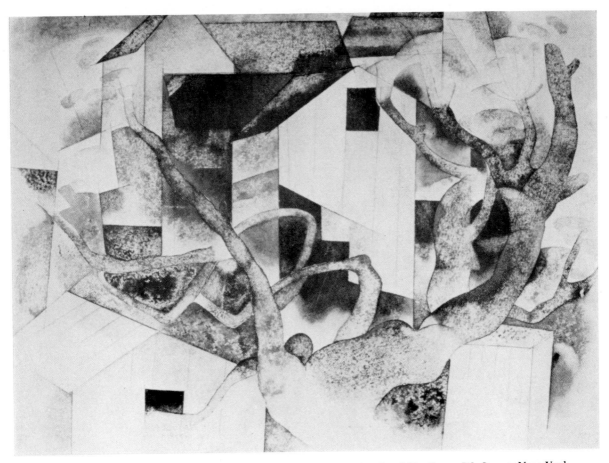

Trees and Barns (Bermuda). 1917. Watercolor, 9½ x 13½". Collection Miss Susan W. Street, New York

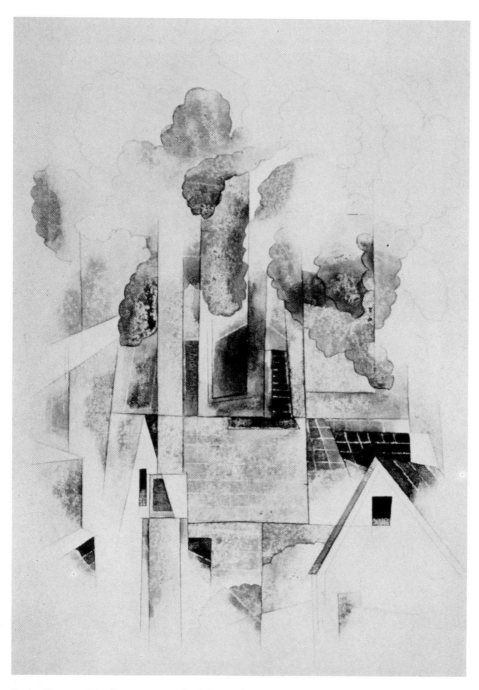

Early Houses, Provincetown. 1918. Watercolor, 14 x 10″. The Museum of Modern Art, gift of Philip L. Goodwin

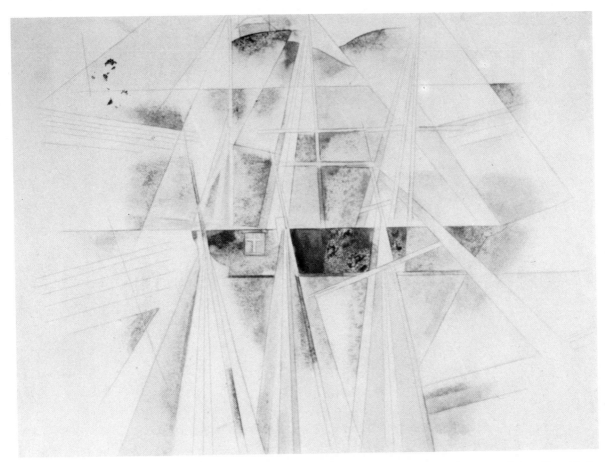

Bermuda, no. 2 (The Schooner). 1917. Watercolor, 10 x 13⅞". The Metropolitan Museum of Art, New York. Bequest of Alfred Stieglitz

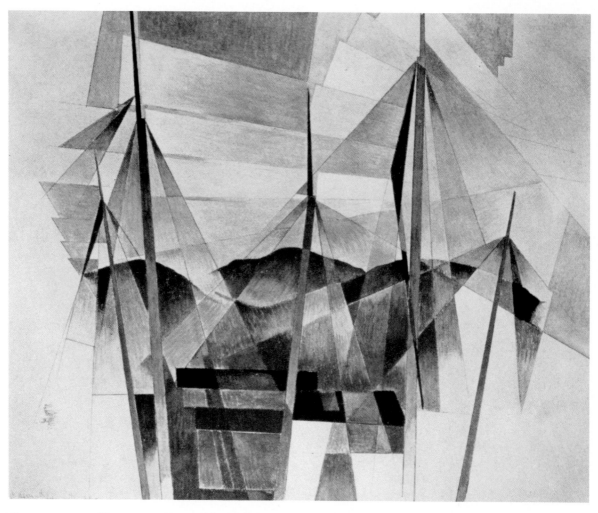

Gloucester. 1919. Tempera, 15½ x 19½″. Museum of Art, Rhode Island School of Design, Providence, R.I.

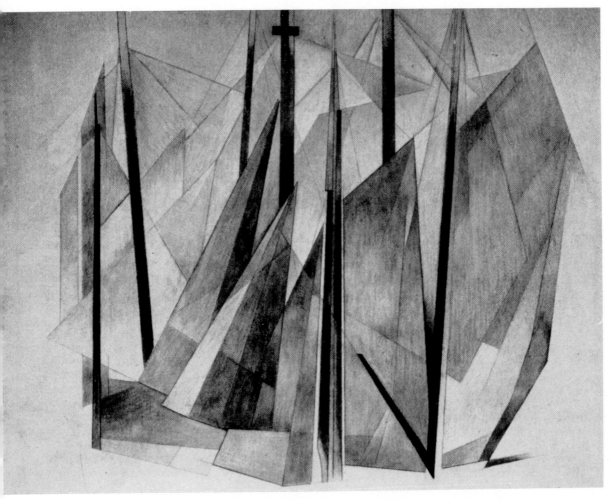

Sails. 1919. Tempera, 15½ x 19″. Santa Barbara Museum of Art, Santa Barbara, Calif.

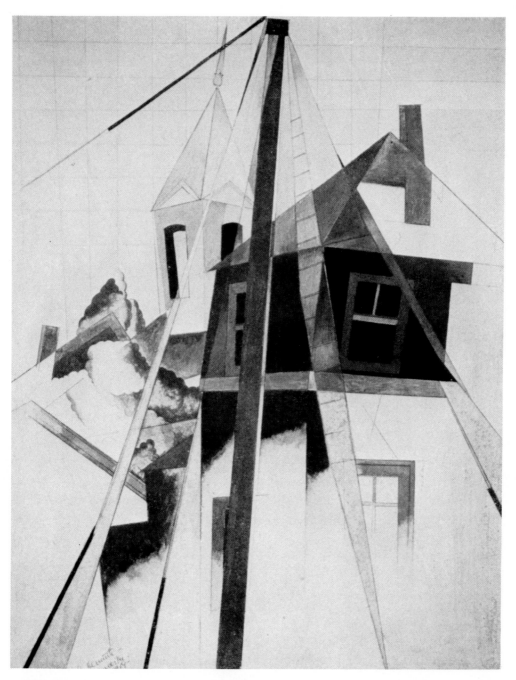

Back-Drop of East Lynne. 1919. Tempera, 19½ x 15½". University of Nebraska Art Galleries, Lincoln, Neb. F. M. Hall Collection

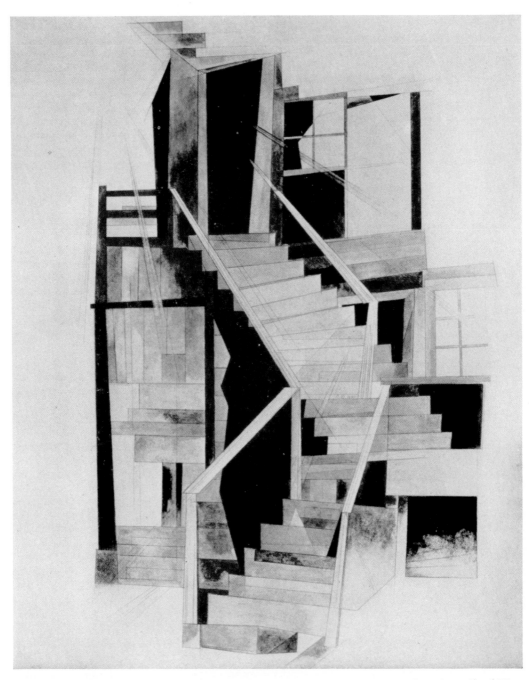

Stairs, Provincetown. 1920. Watercolor, 23½ x 19½″. The Museum of Modern Art, gift of Mrs. John D. Rockefeller, Jr.

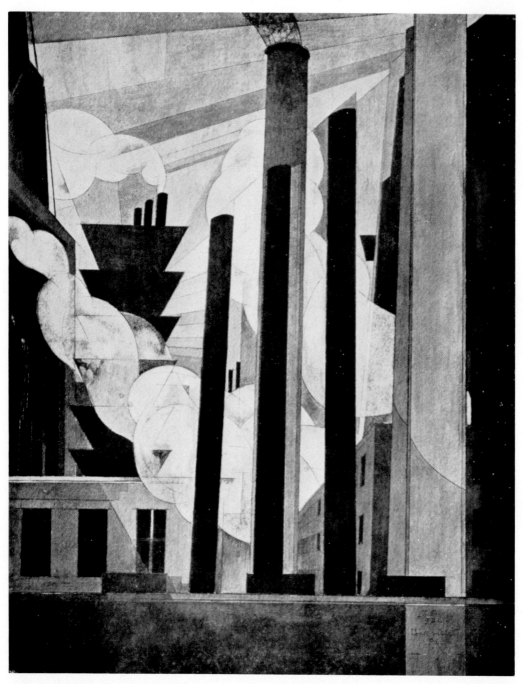

End of the Parade: Coatsville, Pa. 1920. Tempera, 19½ x 15½″. Collection Mr. and Mrs. William Carlos Williams, Rutherford, N.J.

Opposite: *"I Saw the Figure 5 in Gold."* 1928. Oil, 36 x 29¾″. The Metropolitan Museum of Art, New York. Bequest of Alfred Stieglitz

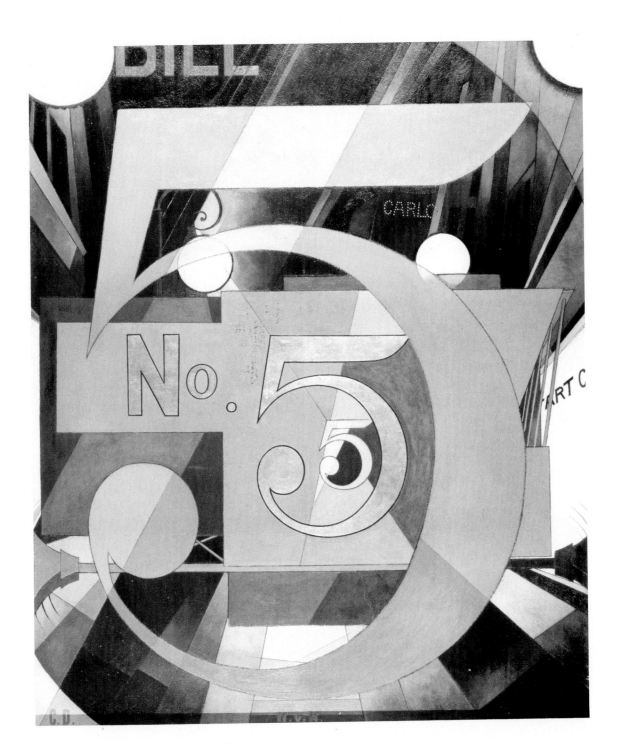

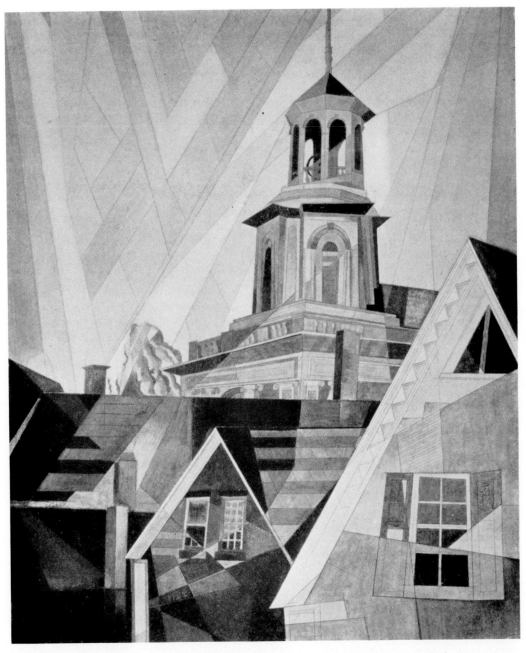

After Sir Christopher Wren. 1920. Tempera, 23⅞ x 20". Anonymous loan through the courtesy of the Worcester Art Museum, Worcester, Mass.

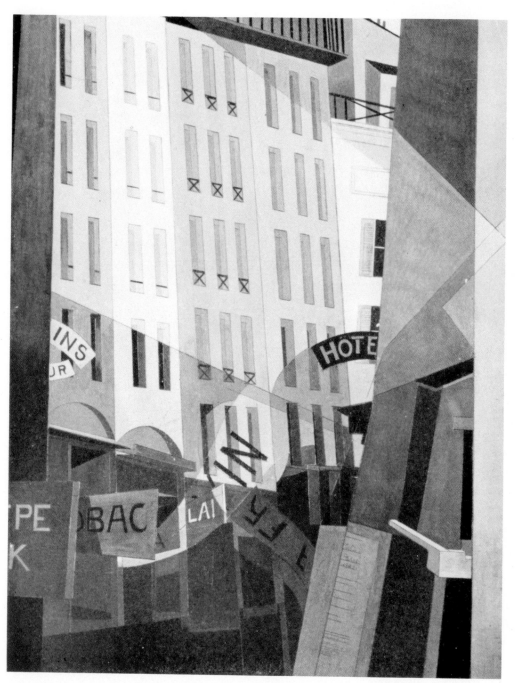

Rue du Singe Qui Pêche. 1921. Tempera, 21 x 16¼″. The Downtown Gallery, New York

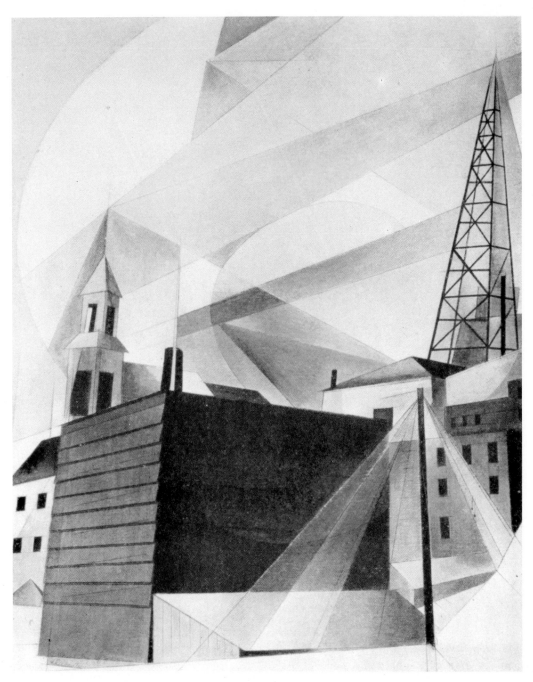

Lancaster. 1921. Tempera, 19 x 15½". Albright Art Gallery, Buffalo, N.Y. Room of Contemporary Art

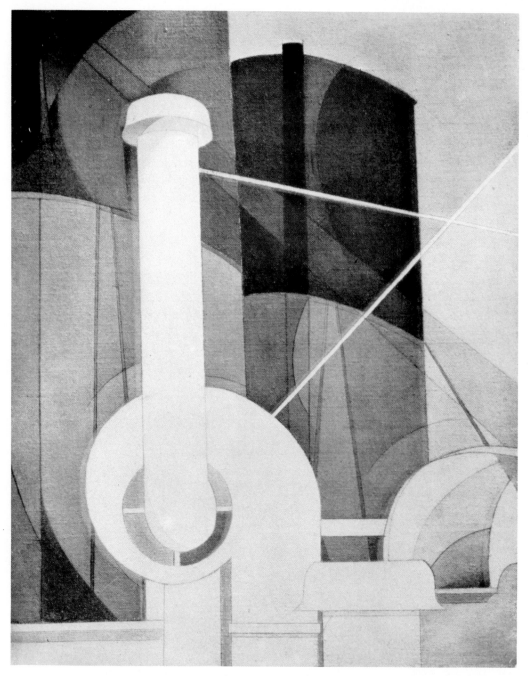

Paquebot Paris. 1921 or '22. Oil, 24½ x 19⁷⁄₁₆″. The Columbus Gallery of Fine Arts, Columbus, Ohio. Ferdinand Howald Collection

Opposite: Two sketches for *Paquebot Paris.* August, 1921. Pencil, each 7⅛ x 5⁵⁄₁₆″. Collection Robert E. Locher, Lancaster, Pa.

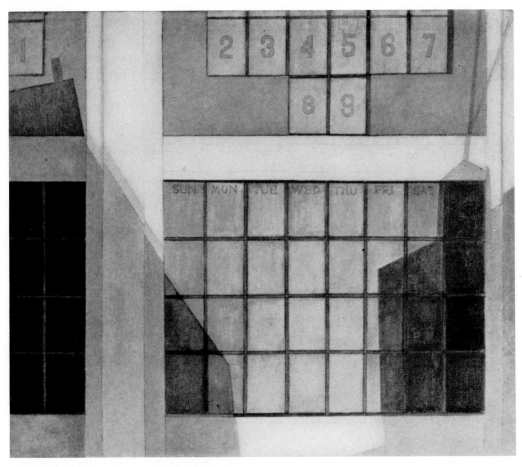

Business. 1921. Oil, 20 x 24¼″. The Art Institute of Chicago, Chicago, Ill. Alfred Stieglitz Collection

 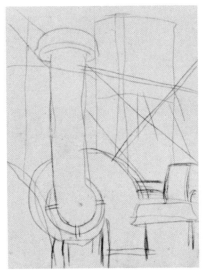

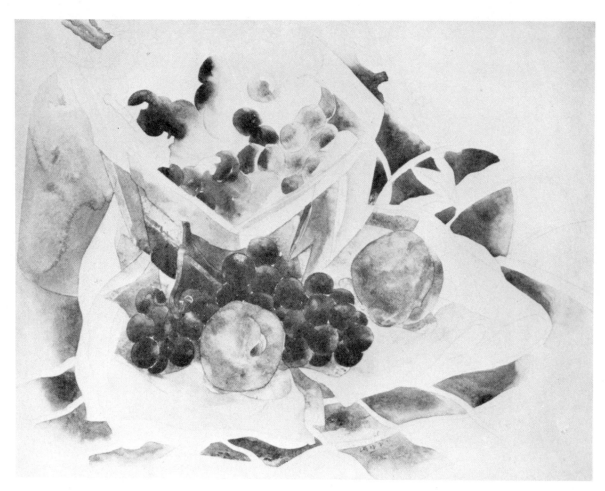

Still Life, No. 2. 1922. Watercolor, $9\frac{9}{16}$ x $12\frac{5}{8}''$. The Columbus Gallery of Fine Arts, Columbus, Ohio. Ferdinand Howald Collection

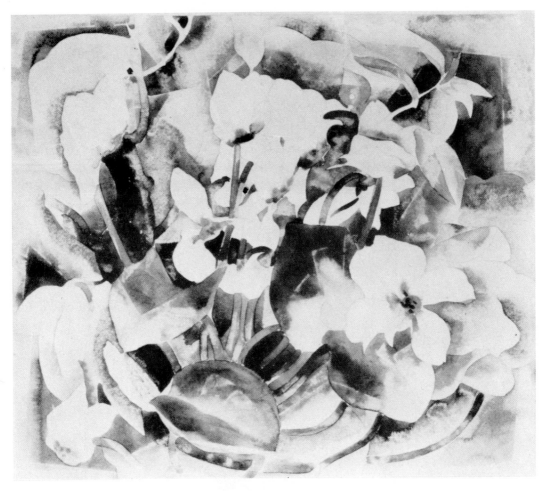

Flowers, Cyclamen. 1920. Watercolor, 11¾ x 13¾". The Art Institute of Chicago, Chicago, Ill.

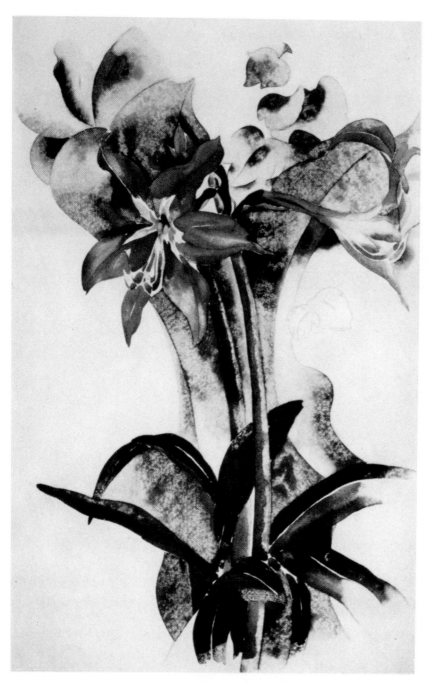

Flower Study. c. 1923. Watercolor, 17½ x 11¾". The Cleveland Museum of Art, Cleveland, Ohio

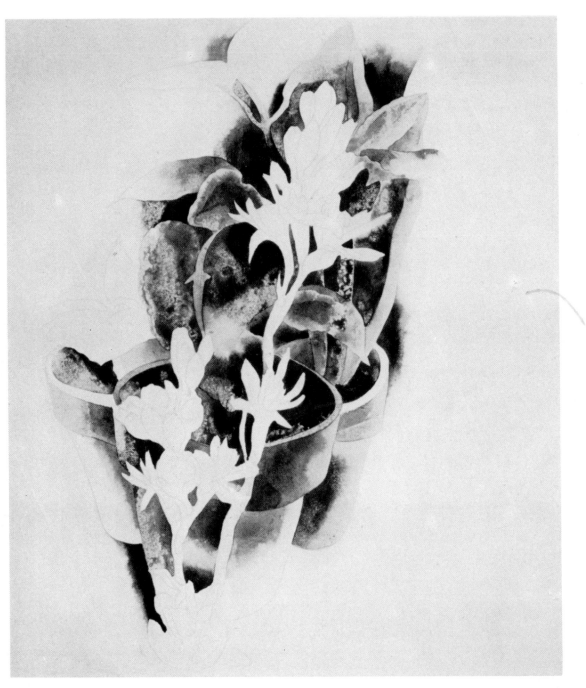

Tuberoses. 1922. Watercolor, 13½ x 11½". Collection Mr. and Mrs. William Carlos Williams, Rutherford, New Jersey

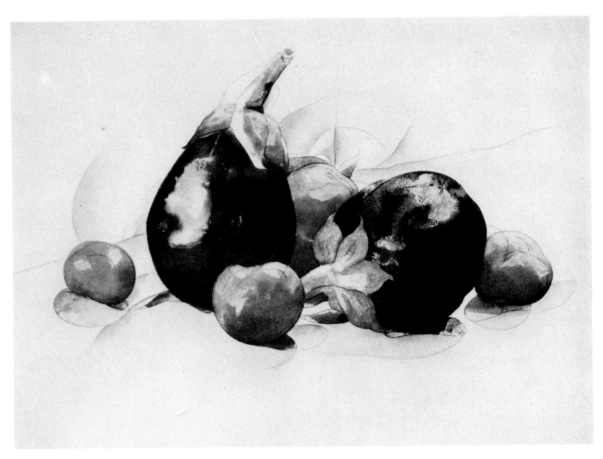

Eggplant and Tomatoes. c. 1927. Watercolor, 19½ x 14″. Collection Richard Weyand, Lancaster, Pa.

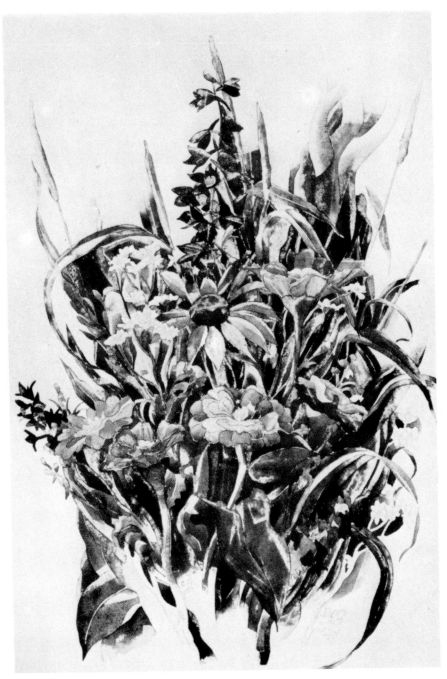

Zinnias, Larkspur and Daisies. 1928. Watercolor, 17½ x 11½". Collection Mrs. B. Lazo Steinman, New York

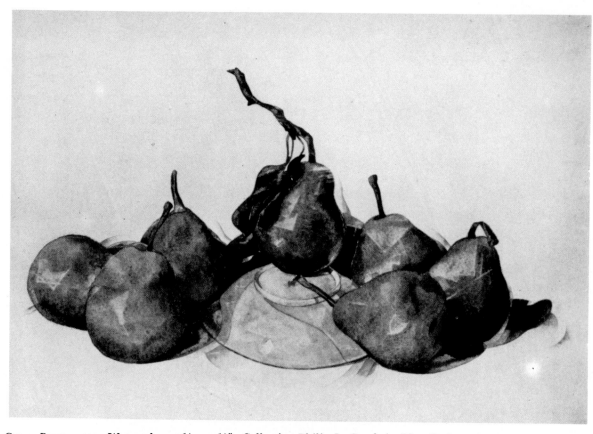

Green Pears. 1929. Watercolor, 13½ x 19½″. Collection Philip L. Goodwin, New York

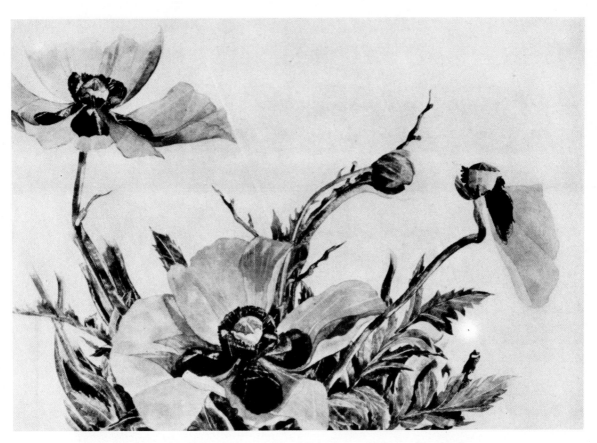

Poppies. 1929. Watercolor, 14 x 20". Collection Mrs. Edith Gregor Halpert, New York

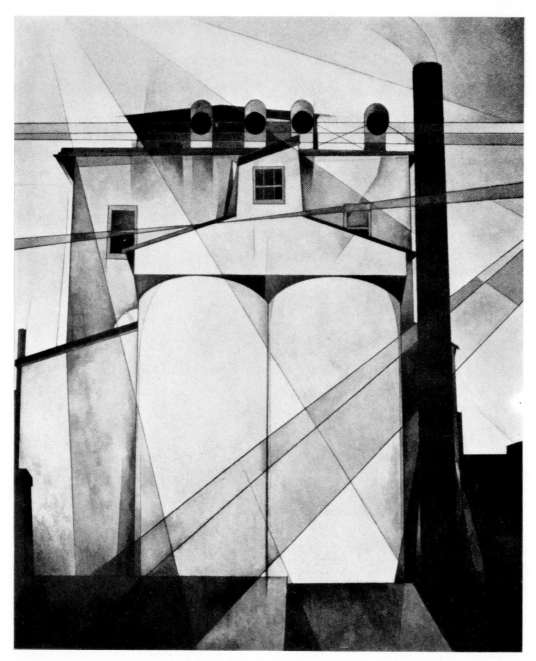

My Egypt. 1927? Oil, 36 x 30″. The Whitney Museum of American Art, New York

Opposite: Two sketches for *My Egypt.* 1927? Pencil, each 8¼ x 6½″. Collection Robert E. Locher, Lancaster, Pa.

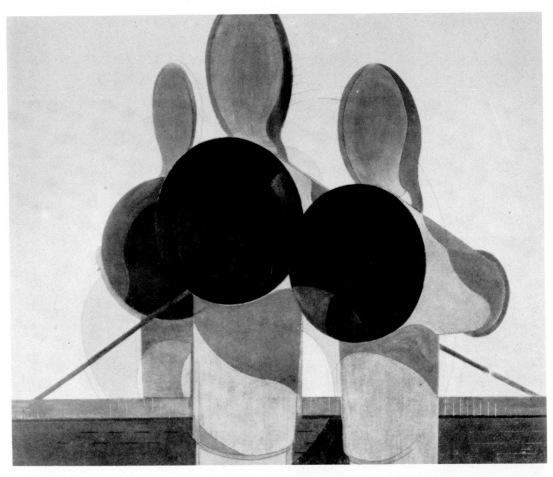

Waiting. 1930. Tempera, 15½ x 19⅝″. The Art Institute of Chicago, Chicago, Ill. Alfred Stieglitz Collection

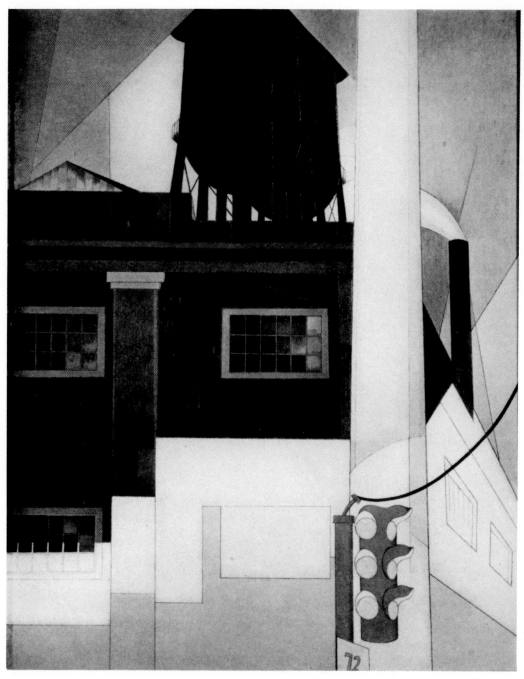

"*...and the Home of the Brave.*" 1931. Oil, 30 x 24". The Art Institute of Chicago, Chicago, Ill. Gift of Miss Georgia O'Keeffe

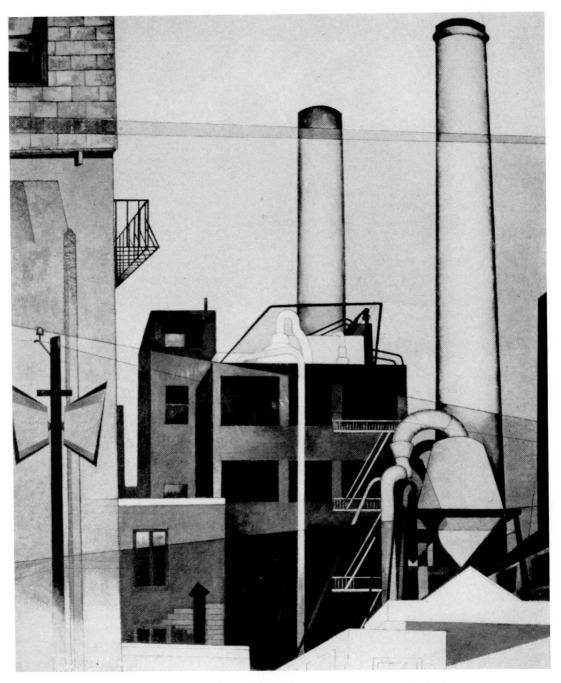

"After All...." 1933. Oil, 36 x 30". Collection Miss Georgia O'Keeffe, New York

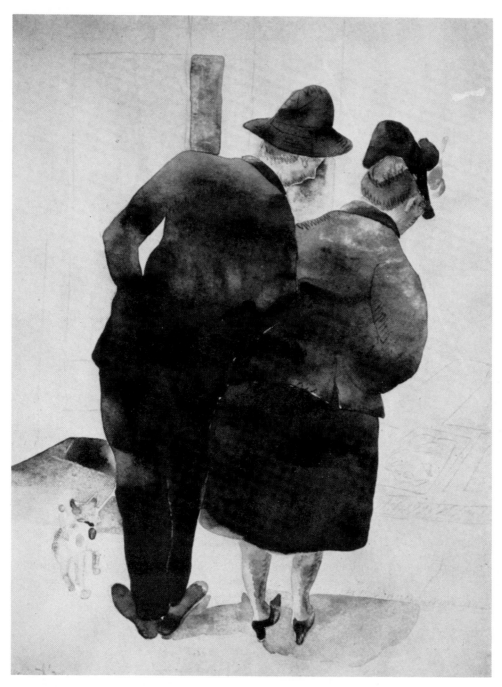

Man and Woman. 1934. Watercolor, 10⅝ x 8¼″. Durlacher Brothers, New York

LENDERS TO THE EXHIBITION

Mrs. James H. Beal, Pittsburgh, Pennsylvania; Louis Bouché, New York; Christopher Demuth, Lancaster, Pennsylvania; Irving Drutman, New York; George J. Dyer, Norfolk, Connecticut; George H. Fitch, New York; Miss Elaine Freeman, New York; A. E. Gallatin, New York; Philip L. Goodwin, New York; Mrs. Chaim Gross, New York; Mrs. Edith Gregor Halpert, New York; Philip Hofer, Rockport, Maine; Robert E. Locher, Lancaster, Pennsylvania; Miss Violette de Mazia, Merion, Pennsylvania; Henry McBride, New York; Miss N. E. Mullen, Merion, Pennsylvania; John S. Newberry, Jr., Grosse Pointe Farms, Michigan; Miss Georgia O'Keeffe, New York; Mrs. Frank C. Osborn, Manchester, Vermont; Mrs. Stanley Resor, New York; Edward W. Root, Clinton, New York; Mrs. B. Lazo Steinman, New York; Miss Ettie Stettheimer, New York; Miss Susan W. Street, New York; Carl Van Vechten, New York; Richard Weyand, Lancaster, Pennsylvania; Mr. and Mrs. S. S. White III, Ardmore, Pennsylvania; Mr. and Mrs. William Carlos Williams, Rutherford, New Jersey.

The Addison Gallery of American Art, Phillips Academy, Andover, Massachusetts; The Albright Art Gallery, Buffalo, New York; The Art Institute of Chicago, Chicago, Illinois; The Cleveland Museum of Art, Cleveland, Ohio; The Columbus Gallery of Fine Arts, Columbus, Ohio; The Detroit Institute of Arts, Detroit, Michigan; Fogg Museum of Art, Harvard University, Cambridge, Massachusetts; The Metropolitan Museum of Art, New York; Museum of Art, Rhode Island School of Design, Providence, Rhode Island; Museum of Fine Arts, Boston, Massachusetts; National Gallery of Art, Washington, D. C.; New Britain Art Museum, New Britain, Connecticut; Philadelphia Museum of Art, Philadelphia, Pennsylvania; The Phillips Gallery, Washington, D. C.; Santa Barbara Museum of Art, Santa Barbara, California; The Toledo Museum of Art, Toledo, Ohio; University of Nebraska Art Galleries, Lincoln, Nebraska; Wadsworth Atheneum, Hartford, Connecticut; The Whitney Museum of American Art, New York; Worcester Art Museum, Worcester, Massachusetts; Yale University Art Gallery, New Haven, Connecticut.

The Downtown Gallery, New York; Durlacher Brothers, New York.

CATALOG OF THE EXHIBITION

An asterisk (*) preceding the catalog number indicates that the picture is illustrated. In listing the dimensions, height precedes width.

1 THE BOXER. 1906 or '07. Conté crayon, 7¼ x 7½". Lent by Robert E. Locher, Lancaster, Pa.

*2 DRAWING. 1906 or '07. Conté crayon, 9½ x 7½". Lent by Robert E. Locher, Lancaster, Pa. *Ill. p.* 19

*3 STUDIO INTERIOR. 1907? Watercolor, 12⅜ x 9½". Lent by Robert E. Locher, Lancaster, Pa. *Ill. p.* 20

4 REVIEW IN PARIS. Paris, 1907? Watercolor, 10½ x 7⅞". Lent by Robert E. Locher, Lancaster, Pa.

5 MLLE OLGA. 1907 or '08. Conté crayon, 5¾ x 4". Lent by Robert E. Locher, Lancaster, Pa.

6 PARROTS. 1911 or '12. Watercolor, 8¼ x 6¾". Lent by Robert E. Locher, Lancaster, Pa.

7 PARIS, THE NIGHT BEFORE CHRISTMAS. 1912. Ink and wash, 10½ x 7¼". Lent by Robert E. Locher, Lancaster, Pa.

8 WHITE HORSE. 1912. Watercolor, 8½ x 5½". Lent by Richard Weyand, Lancaster, Pa.

*9 STROLLING. 1912. Watercolor, 8½ x 5⅛". The Museum of Modern Art, gift of Mrs. John D. Rockefeller, Jr. *Ill. p.* 22

10 TWO MEN WITH WOMAN ON BEACH. 1912. Watercolor, 8½ x 5½". Lent by Robert E. Locher, Lancaster, Pa.

11 MAN AND TWO GIRLS. 1912. Watercolor, 8¼ x 5¼". Lent by Durlacher Brothers, New York

12 SEASCAPE. c. 1912. Watercolor, 9⅞ x 14¹⁄₁₆". The Metropolitan Museum of Art, New York. Bequest of Alfred Stieglitz

13 LANDSCAPE WITH TWO HOUSES. c. 1912. Watercolor, 9⅜ x 12⅝". The Metropolitan Museum of Art, New York. Bequest of Alfred Stieglitz

*14 NEW HOPE, PA. 1911 or '12. Watercolor, 8¾ x 11¾". Robert E. Locher, Lancaster, Pa. *Ill. p.* 21

15 MORNING (Etretat). 1912 or '13. Watercolor, 9¾ x 13¾". Lent by Robert E. Locher, Lancaster, Pa.

16 EARLY LANDSCAPE. 1914. Watercolor, 9⅜ x 12¼". The Metropolitan Museum of Art, New York. Bequest of Alfred Stieglitz

17 THE GOSSIPS. c. 1914. Watercolor, 5 x 8". Lent by Mr. and Mrs. William Carlos Williams, Rutherford, N. J.

18 THE BAY. c. 1915. Watercolor, 10 x 13¾". Lent by The Toledo Museum of Art, Toledo, Ohio

19 THE BOAT. c. 1915. Watercolor, 8½ x 10⅞". Lent by Durlacher Brothers, New York

*20 DUNES. 1915. Watercolor, 11⅜ x 16¹⁄₁₆". The Columbus Gallery of Fine Arts, Columbus, Ohio. Ferdinand Howald Collection. *Ill. p.* 23

21 FLOWERS. c. 1915. Watercolor, 11 x 8½". Lent by The Detroit Institute of Arts, Detroit, Mich.

22 FLOWERS. 1915. Watercolor, 8½ x 11″. The Museum of Modern Art, gift of Mrs. John D. Rockefeller, Jr.

23 YELLOW AND BLUE. 1915. Watercolor, 14 x 10″. The Metropolitan Museum of Art, New York. Bequest of Alfred Stieglitz

*24 PANSIES. 1915. Watercolor, 10¼ x 7¹¹⁄₁₆″. Lent by Mrs. Stanley Resor, New York. *Ill. p. 25*

*25 FLOWER PIECE. 1915. Watercolor, 18 x 11½″. Lent by Miss Susan W. Street, New York. *Ill. p. 26*

26 THE PRIMROSE. c. 1915. Gouache, 15¾ x 11¹⁄₁₆″. The Columbus Gallery of Fine Arts, Columbus, Ohio. Ferdinand Howald Collection

27 POPPIES. c. 1915. Watercolor, 17¾ x 11½″. The Columbus Gallery of Fine Arts, Columbus, Ohio. Ferdinand Howald Collection

*28 FLOWERS. 1915. Watercolor, 13 x 8″. Lent by Louis Bouché, New York. *Ill. p. 24*

29 FISH. c. 1915. Watercolor, 8 x 13″. Lent by Robert E. Locher, Lancaster, Pa.

30 AT MARSHALL'S. 1915. Watercolor, 7⅞ x 10⅛″. Lent by Miss Ettie Stettheimer, New York

31 THE DRINKERS. 1915. Watercolor, 10¾ x 8¼″. The Columbus Gallery of Fine Arts, Columbus, Ohio. Ferdinand Howald Collection

32 VAUDEVILLE CHARACTERS. c. 1915. Watercolor, 10¼ x 7¾″. Lent by Miss Violette de Mazia, Merion, Pa.

33 VAUDEVILLE: BICYCLE ACT. 1915 or '16. Watercolor, 8 x 10½″. Lent by The Mullen Collection, Merion, Pa.

*34 "MANY BRAVE HEARTS ARE ASLEEP IN THE DEEP . . ." 1916. Watercolor, 13 x 8″. Lent by The Mullen Collection, Merion, Pa. *Ill. p. 28*

35 ACROBATS: BALANCING ACT. 1916. Watercolor, 13 x 8″. Lent by The Mullen Collection, Merion, Pa.

*36 VAUDEVILLE: WOMAN WITH WALKING STICK. 1916. Watercolor, 11 x 8″. Lent by The Mullen Collection, Merion, Pa. *Ill. p. 28*

37 MUSICIANS. c. 1916. Watercolor, 10¼ x 7¾″. Lent by The Downtown Gallery, New York

38 REVIEW. 1916. Watercolor, 8 x 10½″. Lent by The Downtown Gallery, New York

39 NEGRO JAZZ BAND. 1916. Watercolor, 13 x 7⅞″. Lent by Henry McBride, New York

40 JUGGLER. 1916. Watercolor, 13 x 8″. Lent by Carl Van Vechten, New York

41 TWO CIRCUS GIRLS. 1916. Watercolor, 8 x 11″. Lent by Mr. and Mrs. S. S. White III, Ardmore, Pa.

*42 THE GREEN DANCER. 1916. Watercolor, 11 x 8″. Lent by Mr. and Mrs. S. S. White III, Ardmore, Pa. *Ill. p. 33*

43 VAUDEVILLE ACT. 1916. Watercolor, 13 x 8″. Lent by Mrs. Chaim Gross, New York

*44 Illustration for Zola's *L'Assommoir*. 1916. Watercolor, 8 x 10½″. The Philadelphia Museum of Art, Philadelphia, Pa. A. E. Gallatin Collection. *Ill. p. 48*

*45 NANA, SEATED LEFT, AND SATIN AT LAURE'S RESTAURANT. Illustration No. 3 for Zola's *Nana* (Chap. VIII). 1916. Watercolor, 8½ x 10¾″. The Museum of Modern Art, gift of Mrs. John D. Rockefeller, Jr. *Ill. p. 38*

*46 NANA BEFORE THE MIRROR. Illustration No. 6 for Zola's *Nana* (Chap. XII). 1916. Watercolor, 7⅞ x 9¾″. Lent by Richard Weyand, Lancaster, Pa. *Ill. p. 41*

*47 SCENE AFTER GEORGES STABS HIMSELF WITH THE SCISSORS (second version). Illustration No. 8 for Zola's *Nana* (Chap. XIII). 1915 or '16. Watercolor, 7¾ x 10″. Lent by Richard Weyand, Lancaster, Pa. *Ill. p. 43*

48 FLOWER PIECE. 1916. Watercolor, 11 x 8⅜″. Lent by Robert E. Locher, Lancaster, Pa.

49 HORSES. 1916. Watercolor, 8 x 11″. Lent by Mr. and Mrs. S. S. White III, Ardmore, Pa.

50 IN THE GYMNASIUM. c. 1916. Watercolor, 10¾ x 8″. Lent by The Fogg Museum of Art, Harvard University, Cambridge, Mass.

51 THE NUT, PRE-VOLSTEAD DAYS. 1916. Watercolor, 10⁹⁄₁₆ x 7¹³⁄₁₆″. The Columbus Gallery of Fine Arts, Columbus, Ohio. Ferdinand Howald Collection

52 THE SHINE. 1916. Watercolor, 7¾ x 10¼″. The Museum of Modern Art, gift of James W. Barney

53 BEACH SCENE. 1916. Watercolor, 7¾ x 9¹⁵⁄₁₆″. Lent by Irving Drutman, New York

54 BERMUDA LANDSCAPE. 1916. Watercolor, 7¾ x 9⅞″. Lent by Mr. and Mrs. S. S. White III, Ardmore, Pa.

55 BERMUDA LANDSCAPE. 1916. Watercolor, 9¾ x 13¹¹⁄₁₆″. The Columbus Gallery of Fine Arts, Columbus, Ohio. Ferdinand Howald Collection

56 BERMUDA, NO. 1 (TREE AND HOUSE). 1917. Watercolor, 10 x 13⅞″. The Metropolitan Museum of Art, New York. Bequest of Alfred Stieglitz

*57 BERMUDA, NO. 2 (THE SCHOONER). 1917. Watercolor, 10 x 13⅞″. The Metropolitan Museum of Art, New York. Bequest of Alfred Stieglitz. *Ill. p. 65*

58 LANDSCAPE INTERPRETATION, BERMUDA. 1917. Watercolor, 10 x 14″. Lent by Mr. and Mrs. S. S. White III, Ardmore, Pa.

*59 TREES AND BARNS (BERMUDA). 1917. Watercolor, 9½ x 13½″. Lent by Miss Susan W. Street, New York. *Ill. p. 63*

60 THE MONUMENT, BERMUDA. 1917. Watercolor, 14 x 10″. The Phillips Gallery, Washington, D. C.

61 TREES. 1917. Watercolor, 9¹¹⁄₁₆ x 13¹¹⁄₁₆″. The Columbus Gallery of Fine Arts, Columbus, Ohio. Ferdinand Howald Collection

62 A RED ROOFED HOUSE. c. 1917. Watercolor, 10 x 14″. Lent by The Downtown Gallery, New York

63 WHITE ARCHITECTURE. 1917. Watercolor, 18 x 11½″. Lent by The Downtown Gallery, New York

64 BEACH, PROVINCETOWN. 1917. Watercolor, 8 x 11″. Lent by Robert E. Locher, Lancaster, Pa.

65 EIGHT O'CLOCK. 1917. Watercolor, 7¾ x 10″. Lent by George J. Dyer, Norfolk, Conn.

66 EIGHT O'CLOCK. 1917. Watercolor, 7⅞ x 10⅛". The Museum of Modern Art, gift of Mrs. John D. Rockefeller, Jr.

*67 VAUDEVILLE. 1917. Watercolor, 8 x 10⅜". Lent by Miss Elaine Freeman, New York. *Ill. p.* 29

*68 THE CIRCUS. 1917. Watercolor, 8 x 10⅝". The Columbus Gallery of Fine Arts, Columbus, Ohio. Ferdinand Howald Collection. *Ill. p.* 35

*69 VAUDEVILLE MUSICIANS. 1917. Watercolor, 13 x 8". The Museum of Modern Art, Mrs. John D. Rockefeller, Jr. Purchase Fund. *Ill. p.* 32

70 SOLDIER ON LEAVE. c. 1917. Watercolor, 10¾ x 7¾". Lent by Miss Violette de Mazia, Merion, Pa.

71 PROVINCETOWN. 1918. Watercolor. Lent by Christopher Demuth, Lancaster, Pa.

72 ARCHITECTURE. 1918. Watercolor, 14 x 10". Lent by Mrs. James H. Beal, Pittsburgh, Pa.

73 HOUSES. 1918. Watercolor, 13¾ x 9¾". The Columbus Gallery of Fine Arts, Columbus, Ohio. Ferdinand Howald Collection

*74 TWO ACROBATS. 1918. Watercolor, 13 x 7½". Lent by Mrs. Edith Gregor Halpert, New York. *Ill. p.* 30

75 RED CHIMNEYS. 1918. Watercolor, 9¾ x 13¾". Lent by The Phillips Gallery, Washington, D. C.

*76 EARLY HOUSES, PROVINCETOWN. 1918. Watercolor, 14 x 10". The Museum of Modern Art, gift of Philip L. Goodwin. *Ill. p.* 64

77 FLOWERS. 1918. Watercolor, 17⅝ x 11⅝". The Metropolitan Museum of Art, New York

*78 DAISIES. 1918. Watercolor, 17½ x 11½". The Whitney Museum of American Art, New York. *Ill. p.* 27

79 POPPIES. 1918. Watercolor, 17½ x 11½". Lent by Edward W. Root, Clinton, N. Y.

*80 ACROBATS. 1918. Watercolor, 10⅞ x 8⅜". Lent by Mrs. Edith Gregor Halpert, New York. *Ill. p.* 31

81 DANCING SAILORS. 1918. Watercolor, 7⅞ x 9⅞". The Museum of Modern Art, Mrs. John D. Rockefeller, Jr. Purchase Fund

*82 THE ANIMAL TAMER PRESENTS LULU. Illustration No. 1 for Wedekind's *Erdgeist*, (Prologue, Act I). 1918. Watercolor, 12 15/16 x 8". Lent by Miss Violette de Mazia, Merion, Pa. *Ill. p.* 49

*83 BOY AND GIRL. Thought to be frontispiece for James's *The Turn of the Screw*. 1912. Watercolor, 8¼ x 5⅛". Lent by Philip Hofer, Rockport, Maine. *Ill. p.* 22

*84 AT A HOUSE IN HARLEY STREET. Illustration No. 1 for James's *The Turn of the Screw* (Prologue). 1918. Watercolor, 8 x 11". The Museum of Modern Art, gift of Mrs. John D. Rockefeller, Jr. *Ill. p.* 53

*85 THE GOVERNESS FIRST SEES THE GHOST OF PETER QUINT. Illustration No. 2 for James's *The Turn of the Screw* (Chap. III). 1918. Watercolor, 8 x 10⅜". Lent by Mrs. Frank C. Osborn, Manchester, Vt. *Ill. p.* 54

*86 FLORA AND THE GOVERNESS. Illustration No. 3 for James's *The Turn of the Screw* (Chap. VI). 1918. Watercolor, 8 x 10⅜". Lent by Mrs. Frank C. Osborn, Manchester, Vt. *Ill. p.* 55

*87 THE GOVERNESS, MRS. GROSE AND THE CHILDREN. Illustration No. 4 for James's *The Turn of the Screw* (Chap. XI). 1918. Watercolor, 8 x 10⅜". Lent by Mrs. Frank C. Osborn, Manchester, Vt. *Ill. p.* 56

*88 MILES AND THE GOVERNESS. Illustration No. 5 for James's *The Turn of the Screw* (Chap. XXIV). 1918. Watercolor, 8 x 10¾". Lent by Mrs. Frank C. Osborn, Manchester, Vt. *Ill. p.* 57

*89 THE BOAT RIDE FROM SORRENTO. Illustration No. 1 for James's *The Beast in the Jungle* (Chap. I). 1919. Watercolor, 8 x 10". Lent by Mrs. Frank C. Osborn, Manchester, Vt. *Ill. p.* 58

*90 THE REVELATION COMES TO MAY BARTRAM IN HER DRAWING-ROOM. Illustration No. 2 for James's *The Beast in the Jungle* (Chap. IV). 1919. Watercolor, 8 x 10". Lent by Mrs. Frank C. Osborn, Manchester, Vt. *Ill. p.* 59

*91 MARCHER RECEIVES HIS REVELATION AT MAY BARTRAM'S TOMB. Illustration No. 3 for James's *The Beast in the Jungle* (Chap. VI). 1919. Watercolor, 8 x 10". Lent by Mrs. Frank C. Osborn, Manchester, Vt. *Ill. p.* 60

*92 Two sketches for MARCHER RECEIVES HIS REVELATION AT MAY BARTRAM'S TOMB. 1919. Pencil, each 8 x 10½". Lent by Robert E. Locher, Lancaster, Pa. *Ill. p.* 61

*93 GLOUCESTER. 1919. Tempera, 15½ x 19½". Lent by the Museum of Art, Rhode Island School of Design, Providence, R. I. *Ill. p.* 66

*94 SAILS. 1919. Tempera, 15½ x 19". Lent by The Santa Barbara Museum of Art, Santa Barbara, Calif. *Ill. p.* 67

*95 BACK-DROP OF EAST LYNNE. 1919. Tempera, 19½ x 15½". Lent by The University of Nebraska Art Galleries, Lincoln, Neb. F. M. Hall Collection. *Ill. p.* 68

96 BOX OF TRICKS. 1919. Tempera, 19⅜ x 15⅜". Lent by The Philadelphia Museum of Art, Philadelphia, Pa.

97 FLOWERS. 1919. Watercolor, 13¾ x 9 11/16". The Columbus Gallery of Fine Arts, Columbus, Ohio. Ferdinand Howald Collection.

98 COLUMBIA. 1919. Watercolor, 11 5/16 x 8". The Columbus Gallery of Fine Arts, Columbus, Ohio Ferdinand Howald Collection

*99 ACROBATS. 1919. Watercolor, 13 x 7⅞". The Museum of Modern Art, gift of Mrs. John D. Rockefeller, Jr. *Color frontispiece*

*100 AT "THE GOLDEN SWAN" SOMETIMES CALLED "HELL HOLE." (Self-portrait with Marcel Duchamp). 1919. Watercolor, 8¼ x 10¾". Lent by Robert E. Locher, Lancaster, Pa. *Ill. p.* 17

101 DUNES. 1920. Watercolor, 9¾ x 14". Lent by Mr. and Mrs. S. S. White III, Ardmore, Pa.

*102 STAIRS, PROVINCETOWN. 1920. Watercolor, 23½ x 19½". The Museum of Modern Art, gift of Mrs. John D. Rockefeller, Jr. *Ill. p.* 69

103 RED CHIMNEY. 1920. Watercolor, 13¾ x 10¾". Lent by Mr. and Mrs. S. S. White III, Ardmore, Pa.

104 THE TOWER. 1920. Tempera, 23½ x 19⁷⁄₁₆". The Columbus Gallery of Fine Arts, Columbus, Ohio. Ferdinand Howald Collection

*105 AFTER SIR CHRISTOPHER WREN. 1920. Tempera, 23⅞ x 20". Lent anonymously through the courtesy of the Worcester Art Museum, Worcester, Mass. *Ill. p.* 71

*106 END OF THE PARADE: COATSVILLE, PA. 1920. Tempera, 19½ x 15½". Lent by Mr. and Mrs. William Carlos Williams, Rutherford, N. J. *Ill. p.* 70

107 MACHINERY. 1920. Tempera, 24 x 19⅞". The Metropolitan Museum of Art, New York. Bequest of Alfred Stieglitz

*108 FLOWERS, CYCLAMEN. 1920. Watercolor, 11¾ x 13¾". Lent by The Art Institute of Chicago, Chicago, Ill. *Ill. p.* 77

109 FUCHIAS. 1920. Watercolor, 9⅞ x 14". Lent by Mr. and Mrs. S. S. White III, Ardmore, Pa.

110 AUGUST LILIES. 1921. Watercolor, 12 x 17¾". Lent by The Whitney Museum of American Art, New York

*111 LANCASTER. 1921. Tempera, 19 x 15½". Albright Art Gallery, Buffalo, N. Y. Room of Contemporary Art. *Ill. p.* 73

*112 BUSINESS. 1921. Oil, 20 x 24¼". The Art Institute of Chicago, Chicago, Ill. Alfred Stieglitz Collection. *Ill. p.* 75

113 MODERN CONVENIENCES. 1921. Oil, 25⁷⁄₁₆ x 20¹⁵⁄₁₆". The Columbus Gallery of Fine Arts, Columbus, Ohio. Ferdinand Howald Collection

114 INCENSE OF A NEW CHURCH. 1921. Oil, 25½ x 19¹³⁄₁₆". The Columbus Gallery of Fine Arts, Columbus, Ohio. Ferdinand Howald Collection

*115 RUE DU SINGE QUI PÊCHE. 1921. Tempera, 21 x 16¼". Lent by The Downtown Gallery, New York. *Ill. p.* 72

116 NOSPMAS M. EGIAP NOSPMAS. 1921 or '22. Oil, 24 x 20". Lent by Mrs. Edith Gregor Halpert, New York

*117 Four sketches for PAQUEBOT PARIS. August, 1921. Pencil, each 7⅛ x 5⁵⁄₁₆". Lent by Robert E. Locher, Lancaster, Pa. *Two ill. p.* 75

*118 PAQUEBOT PARIS. 1921 or '22. Oil, 24½ x 19⁷⁄₁₆". The Columbus Gallery of Fine Arts, Columbus, Ohio. Ferdinand Howald Collection. *Ill. p.* 74

*119 TUBEROSES. 1922. Watercolor, 13½ x 11½". Lent by Mr. and Mrs. William Carlos Williams, Rutherford, N. J. *Ill. p.* 79

120 STILL LIFE, No. 1. c. 1922. Watercolor, 11¾ x 17¾". The Columbus Gallery of Fine Arts, Columbus, Ohio. Ferdinand Howald Collection

*121 STILL LIFE, No. 2. 1922. Watercolor, 9⁹⁄₁₆ x 12⅝". The Columbus Gallery of Fine Arts, Columbus, Ohio. Ferdinand Howald Collection. *Ill. p.* 76

122 STILL LIFE, No. 3. c. 1922. Watercolor, 13½ x 9⅝". The Columbus Gallery of Fine Arts, Columbus, Ohio. Ferdinand Howald Collection

*123 FLOWER STUDY. c. 1923. Watercolor, 17½ x 11¾". Lent by The Cleveland Museum of Art, Cleveland, Ohio. *Ill. p.* 78

124 CALIFORNIA TOMATOES. c. 1923. Watercolor, 11½ x 13¹¹⁄₁₆". The Columbus Gallery of Fine Arts, Columbus, Ohio. Ferdinand Howald Collection

125 EGGPLANT AND PLUMS. c. 1923. Watercolor, 11⅝ x 17¼". Lent by The Art Institute of Chicago, Chicago, Ill.

126 MME DELAUNOIS. 1924. Watercolor, 10⅞ x 8½". Lent by Robert E. Locher, Lancaster, Pa.

127 PEARS. 1924. Watercolor, 11¾ x 17¹⁄₁₆". The Columbus Gallery of Fine Arts, Columbus, Ohio. Ferdinand Howald Collection

128 FRUIT AND SUNFLOWERS. c. 1924. Watercolor, 17⅞ x 11⅝". Lent by The Fogg Museum of Art, Harvard University, Cambridge, Mass.

129 DAISIES. 1925. Watercolor, 12 x 15". Lent by The New Britain Art Museum, New Britain, Conn.

130 FRUIT AND DAISIES. c. 1925 Watercolor, 12 x 18". Lent by The Fogg Museum of Art, Harvard University, Cambridge, Mass.

131 BOWL OF ORANGES. 1925. Watercolor, 13⁷⁄₁₆ x 19³⁄₁₆". The Columbus Gallery of Fine Arts, Columbus, Ohio. Ferdinand Howald Collection

132 PLUMS. 1925. Watercolor, 17¾ x 11¾". Lent by The Addison Gallery of American Art, Phillips Academy, Andover, Mass.

133 ROSES. 1926. Watercolor, 11⅞ x 17¾". Lent by The Museum of Fine Arts, Boston, Mass.

134 STILL LIFE—CARROTS AND APPLES. 1926. Watercolor, 13⅝ x 19⅝". Lent by George H. Fitch, New York

135 STILL LIFE—APPLES AND PEARS. 1926. Watercolor, 13½ x 19½". Lent by The Yale University Art Gallery, New Haven, Conn.

136 EGGPLANT AND SUMMER SQUASH. c. 1927. Watercolor, 13½ x 19¾". Lent by The Wadsworth Atheneum, Hartford, Conn.

*137 EGGPLANT AND TOMATOES. c. 1927. Watercolor, 19½ x 14". Lent by Richard Weyand, Lancaster, Pa. *Ill. p.* 80

*138 MY EGYPT. 1927? (Also dated 1925 or 1929). Oil, 36 x 30". Lent by The Whitney Museum of American Art, New York. *Ill. p.* 84

*139 Two sketches for MY EGYPT. 1927? Pencil, each 8¼ x 6½". Lent by Robert E. Locher, Lancaster, Pa. *Ill. p.* 85

140 LA ROSE NOIRE (Costume for Black and White Ball). 1928. Watercolor, 10¾ x 8¼". Lent by Mrs. B. Lazo Steinman, New York

141 COSTUME AFTER BEARDSLEY (for Black and White Ball). 1928. Watercolor, 10⅝ x 8¼". Lent by Mrs. B. Lazo Steinman, New York

*142 ZINNIAS, LARKSPUR AND DAISIES. 1928. Watercolor, 17½ x 11½". Lent by Mrs. B. Lazo Steinman, New York. *Ill. p.* 81

143 LONGHI ON BROADWAY (Poster portrait of Eugene O'Neill). 1928. Oil, 34 x 27". Lent by Miss Georgia O'Keeffe, New York

*144 "I SAW THE FIGURE 5 IN GOLD." 1928. Oil, 36 x 29¾". The Metropolitan Museum of Art, New York. Bequest of Alfred Stieglitz. *Color plate, opp. p. 70*

*145 GREEN PEARS. 1929. Watercolor, 13½ x 19½". Lent by Philip L. Goodwin, New York. *Ill. p. 82*

146 YELLOW PEARS. c. 1929. Watercolor, 13½ x 19". Lent by John S. Newberry, Jr., Grosse Pointe Farms, Mich.

147 RED CABBAGES, RHUBARB AND ORANGE. 1929. Watercolor, 14 x 19⅞". The Metropolitan Museum of Art, New York. Bequest of Alfred Stieglitz

*148 POPPIES. 1929. Watercolor, 14 x 20". Lent by Mrs. Edith Gregor Halpert, New York. *Ill. p. 83*

149 CALLA LILIES. 1929. Watercolor, 14 x 19¾". Lent by Miss Susan W. Street, New York

150 KISS-ME-OVER-THE-FENCE. 1929. Watercolor, 11⅝ x 17½". Lent by Durlacher Brothers, New York

151 CORN AND PEACHES. 1929. Watercolor, 13¾ x 19¾". The Museum of Modern Art, gift of Mrs. John D Rockefeller, Jr.

*152 WAITING. 1930. Tempera, 15½ x 19⅝". The Art Institute of Chicago, Chicago, Ill. Alfred Stieglitz Collection. *Ill. p. 85*

*153 ". . . AND THE HOME OF THE BRAVE." 1931. Oil, 30 x 24". The Art Institute of Chicago, Chicago, Ill. Gift of Miss Georgia O'Keeffe. *Ill. p. 86*

154 CHIMNEY AND WATERTOWER. 1931. Oil, 29⅞ x 23⅞". Lent by Miss Georgia O'Keeffe, courtesy of The National Gallery of Art, Washington, D. C.

155 ON "THAT" STREET. 1932. Watercolor, 10⅞ x 8½". The Art Institute of Chicago, Chicago, Ill. Alfred Stieglitz Collection

*156 "AFTER ALL . . ." 1933. Oil, 36 x 30". Lent by Miss Georgia O'Keeffe, New York. *Ill. p. 87*

*157 MAN AND WOMAN. 1934. Watercolor, 10⅝ x 8¼". Lent by Durlacher Brothers, New York. *Ill. p. 88*

158 Ten Studies from Provincetown Sketchbook. 1934. Watercolor, each 8½ x 11". Lent by Robert E. Locher, Lancaster, Pa.

BIBLIOGRAPHY

This bibliography, with two exceptions, does not include references to items which have appeared in newspapers. Omitted also are a few references to minor exhibition notices, listed in the Art Index 1929-1949.

Additional material is contained in scrapbooks (3 volumes of typescripts and clippings) on Charles Demuth, in a private collection.

The list of exhibition catalogs is by no means complete, but includes only those catalogs which have been accessible to the compiler. They have been arranged chronologically, as have the references to statements by the artist. References to writings on the artist, however, are listed alphabetically under the author's name, or under the title in case of unsigned articles.

All material, except when preceded by a dagger (†), has been examined by the compiler. Items marked with an asterisk (*) are in the Museum Library.

ANNE BOLLMANN

Abbreviations: Ap April, bibl bibliography, col colored, D December, ed edited, edition, editor, F February, il illustration(s), incl including, Ja January, Je June, Jy July, Mr March, My May, N November, n.d. not dated, n.p. no place, no number(s), O October, p page(s), por portrait, S September, suppl supplement.

Sample entry for magazine article: LANE, JAMES W. Charles Demuth. il *Parnassus* (New York) 8no3:8-9 Mr 1936.

Explanation: An article by James W. Lane, entitled "Charles Demuth" accompanied by illustrations, will be found in *Parnassus* (published in New York), volume 8, number 3, pages 8-9, the March 1936 issue.

STATEMENTS BY THE ARTIST

1 AARON ESHLEMAN, ARTIST. *Lancaster County Historical Society Papers* (Lancaster, Pa.) 16no8:247-50 O 1912.

2 THE AZURE ADDER. *The Glebe* (New York) 1no3:1-31 D 1913.

*3 BETWEEN FOUR AND FIVE. *Camera Work* (New York) no47:32 Jy 1914.
 Reply to a question: "What is '291'?"

4 FILLING A PAGE. A pantomime with words. il *Rogue* (New York) 1no2:13-14 Ap 1 1915.

*5 [STATEMENT] *Manuscripts* (New York) no4:4 D 1922.
 Brief reply to question: "Can a photograph have the significance of art?"

*6 [INTRODUCTION] to exhibition catalog: Intimate Gallery, New York. *Georgia O'Keeffe paintings.* folder New York, 1926.
 Reprinted in bibl. 12.

7 PEGGY BACON. In exhibition catalog: Intimate Gallery, New York. *Peggy Bacon exhibition.* folder New York, 1928.

†8 [FOREWORD] to exhibition catalog, 1928.
 Reprinted in bibl. 12.

9 CONFESSIONS. por *The Little Review* (New York; Paris) 12no2:30-1 My 1929.
 Replies to a questionnaire.

*10 ACROSS A GRECO IS WRITTEN. il (1 col) *Creative Art* (New York) 5:629-34 S 1929.

*11 LIGHTHOUSES AND FOG. In *America and Alfred Stieglitz; a collective portrait,* ed. by Waldo Frank [and others]. p246 New York, Doubleday, Doran, 1934.

* Tribute to Alfred Stieglitz. Reprinted in *Stieglitz memorial portfolio, 1864-1946.* p12 New York, Twice a Year Press, 1947.

*12 [FOREWORD] il *Philadelphia Museum Bulletin* 40: 78-80 My 1945.
Reprinted from bibl. 6,8.

BOOKS, ARTICLES, EXHIBITION REVIEWS

*13 BARNES, ALBERT C. The art in painting. 3rd ed. p342, 345-6 il New York, Harcourt, Brace, 1937.

*14 BORN, WOLFGANG. American landscape painting. p206-8 il New Haven, Yale University Press, 1948.

*15 BROWN, MILTON W. Cubist-realism: an American style. il *Marsyas* (Institute of Fine Arts, New York University) 3:139-60 1943-45.
Demuth: p146-8; bibliographical notes: p159-60.

16 CHARLES DEMUTH. il *Wadsworth Atheneum Bulletin* (Hartford, Conn.) 6no2:12 Ap 1928.
Discussion of Demuth's work in general, and a still life bought by the museum in particular.

*17 CHARLES DEMUTH: AN AMERICAN PLACE. *Art News* (New York) 29:10 Ap 18 1931.
Review of exhibition.

18 CHARLES DEMUTH: INTIMATE GALLERY. *Art News* (New York) 24:7 Ap 10 1926.
Unfavorable review of exhibition. For comment see bibl. 55.

*19 CHARLES DEMUTH — PAINTER. *Index of Twentieth Century Artists* (New York) 2no10:147-50, suppl 2p Jy 1935.
Includes biographical note, lists of exhibitions, reproductions, and a bibliography.

*20 CHENEY, MARTHA CANDLER. Modern art in America. p64, 66 New York, Whittlesey House, 1939.

21 COATES, ROBERT M. The art galleries: Charles Demuth . . . New Yorker (New York) 8no46:48 Ja 1 1938.
Review of memorial exhibition, Whitney Museum of American Art, New York.
CORTISSOZ, ROYAL. See bibl. 66.

*22 DAVIDSON, MARTHA. Demuth, architect of painting; the Whitney's complete show permits a new appraisal. il *Art News* (New York) 36:7-8 D 18 1937.

*23 [FIELD, HAMILTON EASTER] Comment on the arts. il *The Arts* (New York) 1no2:29-43 Ja 1921.
Includes review of Demuth exhibition, Daniel Galleries, New York: p30,31.

24 FOLTZ, JOSEPHINE KIEFFER. An appreciation of Charles Demuth. folder [Lancaster, Pa., 1941].
Mimeographed copy, written by a personal friend for the Demuth memorial exhibition, Franklin and Marshall College, Lancaster, Pa. January 1941.

*25 GALLATIN, ALBERT EUGENE. American water-colourists. p22-4 il (1 col) New York, E. P. Dutton, 1922.

*26 ———Charles Demuth. 24p plus plates (1 col) New York, William Edwin Rudge, 1927.
———See also bibl. 44.

*27 GEORGE, WALDEMAR. Les expositions. il *Amour de l'Art* (Paris) 4:762-65 N 1923.
Includes review of exhibition of American painters, Durand-Ruel Galleries, New York; Demuth: p763,764.

*28 HAGEN, ANGELA E. Demuth watercolors and oils at "An American Place." il *Creative Art* (New York) 8:441-3,449 Je 1931.
Review of exhibition.

*29 HARTLEY, MARSDEN. Adventures in the arts. p100-101 New York, Boni and Liveright, 1921.

30 ———Farewell, Charles. An outline in portraiture of Charles Demuth — painter. In *The New Caravan*, ed. by Alfred Kreymborg, Lewis Mumford, Paul Rosenfeld. p552-62 New York, W. W. Norton, 1936.
Recollections from their 23 years' friendship.

* Text also contained in typescript in unpublished anthology of Hartley's writings *The Spangle of existence.* [n.p.] 1942.

31 HENDERSON, HELEN. Charles Demuth. [6]p [n.d.]. Paper read before The Junior League of Lancaster, November 10, 1947. Typescript in scrapbooks on Charles Demuth (private collection).
HENDERSON, WILLIAM JAMES. See bibl. 45.
JEWELL, EDWARD ALDEN. See bibl. 66.

32 KALONYME, LOUIS. The art makers. Charles Demuth, the magician of water colors leads art season of old favorites and new contenders. *Arts and Decoration* (New York) 26no2:63 D 1926.
Review of exhibition, Daniel Galleries, New York.
———See also bibl. 44.

*33 KENTON, EDNA. Henry James to the ruminant reader: The Turn of the Screw . . . With four drawings by Charles Demuth. il *The Arts* (New York) 6no5:245-55 N 1924.
Discussion of James's work, accompanied by Demuth's illustrations.

*34 KOOTZ, SAMUEL MERVIN. Modern American painters. p30-33 il New York, Brewer & Warren, 1930.

35 LANCASTER FINDS A GENIUS IN ITS RECENT PAST. Demuth brings sharp appraisal of our own possibilities in art. il *Lancaster News* (Lancaster, Pa.) Sunday N 8 1936.

*36 LANE, JAMES W. Charles Demuth. il *Parnassus* (New York) 8no3:8-9 Mr 1936.
General discussion of Demuth's art; does not care for his illustrations. An expansion of this

* article in the author's *Masters in modern art.* p85-92 il Boston, Chapman & Grimes, 1936.

37 ———Notes from New York. il *Apollo* (London) 27:96-8 F 1938.
Includes review of the Demuth memorial exhibition, Whitney Museum of American Art, New York: p96-7.

*38 LEE, SHERMAN E. The illustrative and landscape watercolors of Charles Demuth. il *Art Quarterly* (Detroit, Mich.) 5no2:158-75 Spring 1942.

39 LEVI, JULIEN E. Charles Demuth. [2]p 1939.
Typescript in scrapbooks on Charles Demuth (private collection); with note: "This written for 'Living American art' when 'Calla Lilies' was reproduced by Charles Boni — Feb 21, 1939."

40 McBRIDE, HENRY. Charles Demuth memorial show. Whitney museum honors the famous Pennsylvania flower painter. *The Sun* (New York) p14 Saturday D 18 1937.
One of several critiques on Demuth written for *The Sun* from time to time by this critic.

*41 ———Modern art. *The Dial* (New York) 74:217-19 F 1923.
Includes discussion of Demuth and his exhibition at Daniel Galleries, New York, December 1922: p217-18.

*42 ———Water-colours by Charles Demuth. il *Creative Art* (New York) 5:634-5 S 1929.
———See also bibl. 77.

43 MALONE, MRS. JOHN E. Charles Demuth. il *Lancaster County Historical Society Papers* (Lancaster, Pa.) 52no1:1-18 1948.
Paper read before the Lancaster County Historical Society on the occasion of the exhibition at Franklin and Marshall College, Lancaster, January 1948. Includes catalog of the exhibition: p15.

44 MARIN AND DEMUTH, WIZARDS OF WATER COLOR. il *Art Alliance Bulletin* (Philadelphia) F 1939 p[1, 9-10].
Announcement of exhibition to be held February 14 to March 5, including quotations from writings by A. E. Gallatin and Louis Kalonyme.

45 MATHER, FRANK JEWETT, JR.; MOREY, CHARLES RUFUS; HENDERSON, WILLIAM JAMES. The American spirit in art. p165 il New Haven, Yale University Press, 1927.

*46 MELLQUIST, JEROME. The emergence of an American art. p336-40 il New York, Charles Scribners', 1942.
MOREY, CHARLES RUFUS. See bibl. 45.

*47 MORRIS, GEORGE L. K. Some personal letters to American artists recently exhibiting in New York. *Partisan Review* (New York) 4no4:36-41 Mr 1938.
Letter to Charles Demuth, written on the occasion of the memorial exhibition, Whitney Museum of American Art, New York: p38-9.

*48 MURRELL, WILLIAM. Charles Demuth. 54p incl plates New York, Whitney Museum of American Art, [1931]. (American Artists Series).
Includes bibliography.

*49 PHILLIPS, DUNCAN. A collection in the making. p64 il New York, E. Weyhe, 1926.

50 [PINK DRESS: ADDITION TO THE WRIGHT COLLECTION] il *Springfield Museum of Fine Arts Bulletin* (Springfield, Mass.) 15no3:1-2,3 F 1949.
Discussion of Demuth's art, with special reference to "Pink Dress," bought for the museum. Includes quotation from bibl. 56.

*51 RICH, DANIEL CATTON. The Stieglitz collection. il *Bulletin of the Art Institute of Chicago* 43no4:67-71 N 15 1949.
Demuth: p65,66.

*52 ROSENFELD, PAUL. American painting. *The Dial* (New York) 71:649-70 D 1921.
Demuth: p662-3.

53 ———Charles Demuth. *The Nation* (New York) 133:371-3 O 7 1931.
Extensive review of retrospective exhibition, An American Place, Spring 1931.

*54 SCHNACKENBERG, H. E. Charles Demuth. *The Arts* (New York) 17no8:581 My 1931.
Review of exhibition, An American Place, New York.

55 SELIGMANN, HERBERT J. Letter. *Art News* (New York) 24:6 Ap 17 1926.
Reply to unfavorable criticism of Demuth's work (see bibl. 18).

*56 SOBY, JAMES THRALL. Contemporary painters. p9-15 il New York, Museum of Modern Art, 1948.

57 [STIEGLITZ, ALFRED] ["My Egypt"] [1]p New York, An American Place, 1935. ("It must be said" no4).

*58 STRAND, PAUL. American water colors at the Brooklyn museum. *The Arts* (New York) 2no3:148-52 D 1921.
Review of exhibition. Demuth: p151.

*59 SWEENEY, JAMES JOHNSON. L'art contemporain aux États Unis. il *Cahiers d'Arts* (Paris) 13no1/2:43-68 1938.
Demuth: p51,61,68.

*60 SWEENEY, JOHN L. The Demuth pictures. il *Kenyon Review* (Gambier, Ohio) 5:522-32 Autumn 1943.
Discussion of the illustrations for Henry James's stories in general, and "The Beast in the Jungle" in particular.

*61 VAN VECHTEN, CARL. Charles Demuth and Florine Stettheimer. *The Reviewer* (Richmond, Va.) 2no 4:269-70 F 1922.

62 WATER COLOR — A WEAPON OF WIT. Art critics dispute the diabolic delicacies of Charles Demuth's brush. il *Current Opinion* (New York) 66no1:51-2 Ja 1919.
Includes quotations from criticism in *New York Times, The Sun* (New York), and *New York Evening Post.*

63 WATSON, FORBES. Prints and paintings in great variety feature December exhibitions. il *Arts and Decoration* (New York) 14no3:214-15,230 Ja 1921.
Demuth, review of exhibition at Daniel Galleries, New York: p215,230.

*64 ———Charles Demuth. il *The Arts* (New York) 3no1:74-80 Ja 1923.

*65 WELLMAN, RITA. Pen portraits: Charles Demuth. por *Creative Art* (New York) 9:483-4 D 1931.
Recollections from their student days at Pennsylvania Academy of Fine Arts, and later life.

*66 WHITNEY HOLDS MEMORIAL TO CHARLES DEMUTH. il *Art Digest* (New York) 12:5 Ja 1938.

> Includes quotations from Edward Alden Jewell and Royal Cortissoz.

*67 WIGHT, FREDERICK S. Milestones of American painting in our century. p46-7 il (col) Boston, Institute of Contemporary Art; New York, Chanticleer Press, 1949.

> The book is a "product of an exhibition," January 20-March 1, 1949.

68 WRIGHT, WILLARD HUNTINGTON. The new painting and American snobbery. il *Arts and Decoration* (New York) 7no3:129-30,152-4 Ja 1917.

> Demuth: p152.

*69 ———Modern art: Four exhibitions of the new style of painting. il *International Studio* (New York) 60no239:XCVII-VIII Ja 1917.

> Review of exhibition, Daniel Galleries, New York.

EXHIBITION CATALOGS

70 DANIEL GALLERY, NEW YORK. Exhibition of water-colors by Charles Demuth, on view until November 9. folder [1915].

> Lists 29 works plus "Drawings."

71 ———Recent paintings by Charles Demuth. Closing January 2nd, 1923. folder il [1922].

> Lists 12 works. Reviewed in bibl. 41.

*72 ANDERSON GALLERIES, NEW YORK. Alfred Stieglitz presents seven Americans. 159 paintings, photographs & things, recent & never before publicly shown. 16p plus plates. 1925.

> On exhibition March 9-28, 1925. Lists 6 works by Demuth, Portrait posters: p11. Reviewed in *Art News* (New York) 23:5 Mr 14 1925.

73 INTIMATE GALLERY, NEW YORK. Charles Demuth: five paintings, April 29-May 18. folder 1929.

74 DOWNTOWN GALLERY, NEW YORK. 7 masters of water color. 4p il [1931].

> Exhibition held March 16-30, 1931. Lists 4 works by Demuth.

75 SMITH COLLEGE MUSEUM OF ART, NORTHAMPTON, MASS. 5 Americans, May 19-June 19. folder [1934].

> Lists 12 works by Demuth.

*76 [MINNESOTA. UNIVERSITY. UNIVERSITY GALLERY] 5 painters. 13 p Minneapolis, 1937.

> "Charles Demuth," biographical note and catalog, listing 5 works: p4-5.

*77 WHITNEY MUSEUM OF AMERICAN ART, NEW YORK. Charles Demuth memorial exhibition, December 15, 1937 to January 16, 1938. 19p il, 1937.

> Lists 122 works. Includes, besides "Biographical note," an essay by Henry McBride "Charles De-
* muth, artist," reprinted in *Magazine of Art*

(Washington, D. C.) 31:21-3,58 il Ja 1938. Exhibition reviewed by Royal Cortissoz in *New York Herald Tribune* section VII p8 D 19 1937, by E. A. Jewell in *New York Times* D 19 1937, and in bibl. 21, 22, 37, 40, 66.

78 FRANKLIN AND MARSHALL COLLEGE. FACKENTHAL LIBRARY, LANCASTER, PA. Memorial exhibition — watercolors by Charles Demuth 1883-1935 . . . January 20th to 26th. folder 1941.

> Lists 26 works. Exhibition sponsored by the Junior League of Lancaster, Arts Committee. See also bibl. 24.

*79 CINCINNATI ART MUSEUM. A new realism: Crawford, Demuth, Sheeler, Spencer. March 12-April 7. 16p il, 1941.

> Exhibition sponsored by Cincinnati Modern Art Society. Demuth: biographical note including statements by the artist (reprinted from bibl. 10), p6-7; catalog, listing 10 works, p13.

80 PHILLIPS MEMORIAL GALLERY, WASHINGTON, D. C. Charles Demuth: exhibition of water colors and oil paintings, May 3 to 25. folder 1942.

* > Lists 56 works. Reviewed in *Art News* (New York) 41:7 My 15 1942.

*81 PHILADELPHIA MUSEUM OF ART. History of an American: Alfred Stieglitz: "291" and after. Selections from the Stieglitz collection. 37p [1944].

> "Charles Demuth," biographical note and catalog, listing 18 works: p36.

*82 CHICAGO. UNIVERSITY OF CHICAGO. THE RENAISSANCE SOCIETY. Exhibition of paintings by Maurice Prendergast, with watercolors by Charles Demuth and Carl Kahler. January 29-February 28. [3]p, 1946.

> "Charles Demuth," biographical note and catalog, listing 10 works: p[2].

83 COLEMAN ART GALLERY, PHILADELPHIA. 5 prodigal sons, former Philadelphia artists: Ralston Crawford, Stuart Davis, Charles Demuth, Julian Levi, Charles Sheeler. October fourth to thirtieth. folder 1947.

> Lists 4 works by Demuth.

84 FRANKLIN AND MARSHALL COLLEGE. FACKENTHAL LIBRARY, LANCASTER, PA. Twenty-nine watercolors by Charles Demuth, on exhibition . . . January 3 through 11. folder 1948.

> Exhibition sponsored by Lancaster County Historical Society and Fackenthal Library. See also bibl. 43.

*85 ALBERTINA, VIENNA. Amerikanische Meister des Aquarells. Ausstellung, Herbst 1949. 20p Wien, Anton Schroll, 1949.

> "Charles Demuth," biographical note and catalog, listing 7 works: p13-14.

THE MUSEUM OF MODERN ART PUBLICATIONS IN REPRINT
AN ARNO PRESS COLLECTION

Abbott, Jere. *Lautrec-Redon.* 1931

Art in Progress. 1944

Barr, Alfred H., Jr., ed. *Art in Our Time.* 1939

Barr, Alfred H., Jr. *Cézanne, Gauguin, Seurat, Van Gogh.* 1929

Barr, Alfred H., Jr. *Cubism and Abstract Art.* 1936

Barr, Alfred H., Jr. *Fantastic Art, Dada, Surrealism.* 1936, 1937, 1947

Barr, Alfred H., Jr. *Matisse, His Art and His Public.* 1951

Barr, Alfred H., Jr. *Modern German Painting and Sculpture.* 1931

Barr, Alfred H., Jr. *The New American Painting as Shown in Eight European Countries.* 1958-59

Barr, Alfred H., Jr. *Picasso: Fifty Years of His Art.* 1946-55

Barr, Alfred H., Jr. *Vincent Van Gogh.* 1935-42

Barr, Alfred H., Jr., et al. *Three American Modernist Painters: Max Weber, Maurice Sterne, Stuart Davis.* 1930, 1933, 1950

Barr, Alfred H., Jr., Henry McBride, Andrew Carnduff Ritchie. *Three American Romantic Painters: Burchfield, Stettheimer, Watkins.* 1930, 1946, 1950

Barr, Alfred H., Jr., Lincoln Kirstein, Julien Levy. *American Art of the 20's and 30's.* 1929, 1930, 1932

Barr, Margaret Scolari. *Medardo Rosso.* 1963

Bayer, Herbert, Walter Gropius, Ise Gropius. *Bauhaus: 1919-1928.* 1938

Bennett, Wendell C., and René d'Harnoncourt. *Ancient Art of the Andes.* 1954

Cahill, Holger. *American Folk Art.* 1932

Cahill, Holger. *American Painting and Sculpture: 1862-1932.* 1932

Cahill, Holger. *American Sources of Modern Art.* 1933

Cahill, Holger. *New Horizons in American Art.* 1936

Cahill, Holger, et al. *Masters of Popular Painting.* 1938

Douglas, Frederic H., and René d'Harnoncourt. *Indian Art of the United States.* 1941

Drexler, Arthur. *The Architecture of Japan.* 1955

Eliot, T.S., Herbert Read, et al. *Britain at War.* 1941

The Film Index: A Bibliography. 1941

Frobenius, Leo, and Douglas C. Fox. *Prehistoric Rock Pictures in Europe and Africa.* 1937

Haftmann, Werner, Alfred Hentzen, William S. Lieberman. *German Art of the Twentieth Century.* 1957

Hitchcock, Henry-Russell. *Latin American Architecture Since 1945.* 1955

Hitchcock, Henry-Russell, Philip Johnson, Lewis Mumford. *Modern Architecture: International Exhibition.* 1932

Hitchcock, Henry-Russell, and Catherine K. Bauer. *Modern Architecture in England.* 1937

Jayakar, Pupul, and John Irwin. *Textiles and Ornaments of India.* 1956

Johnson, Philip. *Machine Art.* 1934

Kaufmann, Edgar, Jr. *What Is Modern Design?* and *What Is Modern Interior Design?* 1950-53

Paul Klee: *Three Exhibitions.* 1930, 1941, 1949

Lieberman, William S. *Max Ernst.* 1961

Lieberman, William S. *Edvard Munch.* 1957

Linton, Ralph, and Paul Wingert. *Arts of the South Seas.* 1946

McBride, Henry, Marsden Hartley, E.M. Benson. *John Marin.* 1936

Miller, Dorothy C., ed. *Americans 1942-1963: Six Group Exhibitions.* 1942-63

Miller, Dorothy C., and Alfred H. Barr, Jr. *American Realists and Magic Realists.* 1943

Mock, Elizabeth B. *The Architecture of Bridges.* 1949

Mock, Elizabeth B., Henry-Russell Hitchcock, Arthur Drexler. *Built in U.S.A.: 1932-1944* and *Post-War Architecture.* 1944-52

Noyes, Eliot F. *Organic Design in Home Furnishings.* 1941

Paine, Frances Flynn. *Diego Rivera.* 1931

Read, Herbert, et al. *Five European Sculptors.* 1930-48

Rich, Daniel Catton. *Henri Rousseau.* 1946

Ritchie, Andrew Carnduff. *Abstract Painting and Sculpture in America.* 1951

Ritchie, Andrew Carnduff. *Charles Demuth.* 1950

Ritchie, Andrew Carnduff. *Masters of British Painting 1800-1950.* 1956

Ritchie, Andrew Carnduff. *Sculpture of the Twentieth Century*. 1952

Ritchie, Andrew Carnduff, et al. *Three Painters of America: Charles Demuth, Charles Sheeler, Edward Hopper*. 1933, 1939, 1950

Ritchie, Andrew Carnduff. *Edouard Vuillard*. 1954

Rogers, Meyric R., et al. *Four American Painters: Bingham, Homer, Ryder, Eakins*. 1930-35

Schardt, Alois J., et al. *Feininger-Hartley*. 1944

Seitz, William C. *Arshile Gorky*. 1962

Seitz, William C. *Hans Hofmann*. 1963

Seitz, William C. *Claude Monet*. 1960

Seitz, William C. *Mark Tobey*. 1962

Selz, Peter. *Max Beckmann*. 1964

Selz, Peter. *The Work of Jean Dubuffet*. 1962

Selz, Peter. *New Images of Man*. 1959

Selz, Peter. *Emil Nolde*. 1963

Selz, Peter. *Mark Rothko*. 1961

Selz, Peter, and Mildred Constantine, eds. *Art Nouveau*. 1961

Soby, James Thrall, ed., *Arp*. 1958

Soby, James Thrall. *Giorgio de Chirico*. 1955

Soby, James Thrall. *Contemporary Painters*. 1948

Soby, James Thrall. *Salvador Dali*. 1946

Soby, James Thrall. *Juan Gris*. 1958

Soby, James Thrall. *Joan Miró*. 1959

Soby, James Thrall. *Modigliani*. 1951

Soby, James Thrall. *Georges Rouault*. 1947

Soby, James Thrall. *Yves Tanguy*. 1955

Soby, James Thrall. *Tchelitchew*. 1942

Soby, James Thrall, and Dorothy C. Miller. *Romantic Painting in America*. 1943

Soby, James Thrall, and Alfred H. Barr, Jr. *Twentieth-Century Italian Art*. 1949

Sweeney, James Johnson. *African Negro Art*. 1935

Sweeney, James Johnson. *Marc Chagall*. 1946

Sweeney, James Johnson, et al. *Five American Sculptors*. 1935-54

Sweeney, James Johnson. *Joan Miró*. 1941

Tannenbaum, Libby. *James Ensor*. 1951

Twenty Centuries of Mexican Art. 1940

Wheeler, Monroe. *Soutine*. 1950